Denis Thomas

ABSTRACT PAINTING

PHAIDON

For Paul

Phaidon Press Limited, Littlegate House, St Ebbe's Street, Oxford
Published in the United States of America by E. P. Dutton & Co., Inc.

First published 1976

© *1976 Elsevier Publishing Projects SA, Lausanne/Smeets Illustrated*
Projects, Weert

ISBN 0 7148 1746 5
Library of Congress Catalog Card Number : 76–1535

Printed in The Netherlands

ABSTRACT PAINTING

The idea that art is not necessarily born of the material world, but also resides in private forms that belong to the spirit, was already old when Paul Cézanne (1839–1906) told Émile Bernard: 'One must make a vision for oneself, an optic. One must see nature as no one has seen it before.' When Bernard asked if that would not result in a vision incomprehensible to others, Cézanne replied: 'I mean by an optic a logical vision; that is, with nothing of the absurd.'

The master's 'logical vision', vouchsafed to the following generation of painters through the posthumous exhibition of 1907, helped to loosen the last constraints on artists' visual imaginations. Impressionism had shown that the light by which painters see can itself reduce the physical world to abstract forms. The Cubists, building on the example of Cézanne, brought an analytical intelligence to the treatment of material objects, representing them in more than one plane and as a presence in space. They are the true progenitors of Abstract painting, which in its various manifestations has had a longer life than any style of the past hundred years. It has replaced substance with suggestion, images with ideas, in ways that have brought painting, of all the arts, closest to the twentieth-century human condition.

This achievement has been hard won, and not all the leading painters of the age have played a full part in it. Picasso is a notable example: after bringing Cubism to its highest level of painterly abstraction – a distinction he shares with Braque – he deliberately removed himself from the Cubist movement so as to remain free of what he saw as restricting cliques and 'isms'. Matisse, too, remained outside the various groups which for fifty years advanced the Abstract cause. Speaking of the Cubists towards the end of his life, he remarked: 'I had my own work to do. There was perhaps a concordance between my work and theirs. But perhaps they were trying to find me. . .'

Braque, for his part, had a private purity which isolated him even when his impulses touched on those of the Abstract painters: 'Without having striven for it, I do in the end change the meaning of objects and give them a pictorial significance which is adequate to their new life. . . Is not the poet's role in life to provoke continual transformations?' So it is; and in our own age the painter's function is probably even nearer to the poet's than in times past. The personalized use of symbols, the borrowings, puns and paradoxes all have their counterparts in Abstract painting.

At first, these were not characteristics that attracted patrons. At a time when public awareness of painting was growing, people still found themselves at some distance from contemporary art, wondering, 'What does it mean? Is it serious? Can it possibly be Art?' It was as if, despite the heroic struggle of the Impressionists, most of whom had won through from contemptuous neglect to ultimate recognition in the Louvre, the battle now had to be fought all over again.

In their efforts to find a new, liberating language, modern painters found even closer affinities with music. Guillaume Apollinaire, himself a poet, drew attention to this aspect of his friends' work in the pages of *Les Soirées de Paris* in 1912. He wrote that while the aim of painting remained, as always, to give pleasure to the eye, the art-lover was henceforth being asked to expect delights other than those which could be easily provided by looking at natural objects. 'We are moving towards an entirely new art which will stand, with respect to painting as we have known it, as music stands to literature. . . The new painters will provide their admirers with artistic sensations, by concentrating on the problem of creating harmony with unequal lights.'

Long before Apollinaire, Baudelaire (1821–67) had detected musical qualities in modern painting, especially in the colours of Delacroix. The analogy with music

was quickly recognized by Robert Delaunay, and by Wassily Kandinsky. According to Kandinsky, sensitive people respond to colours much as they respond to the vibrations of an instrument under a musician's hand. Some colours can be described as rough or prickly, others as smooth and velvety, 'so that we feel inclined to stroke them'. Even the distinction between warm and cool colours is based, he suggested, on this discrimination. 'Colour is the keyboard, the eyes are the hammers, the soul is the piano with many strings. The artist is the hand that plays, touching one key or another to cause vibrations in the soul.' Yellow, to Kandinsky, was a 'terrestrial' colour; blue was 'celestial'; white 'a vast silence'; black 'an emptiness devoid of all possibility'.

Musicians figure in the painters' company, notably Schoenberg, Webern and Alban Berg, all of whom wrote for the Blaue Reiter group's magazine. Paul Klee's parents were musicians, and Klee himself was an accomplished violinist. Of Beethoven he once wrote that he gives shapes to themes that are lodged in the interior itself – an apt description of Klee's own procedure in painting. In his book on Juan Gris, Kahnweiler, Picasso's dealer, likens Cubism to twelve-tone music; and music makes frequent appearances in Cubist paintings, usually as an instrument or as a snatch of musical notation. In critical jargon, the term 'polyphonic' is applied to Abstract painting to express the tight intermeshing of disparate parts in a harmonious whole. Francis Picabia's *Udnie* (Plate 3) was inspired by a dancer. Jazz provides the energy in Picasso's *The Three Dancers*, and in Piet Mondrian's last painting, *Victory Boogie-Woogie*, nearly twenty years later.

These associations with other arts help to relate the modern movement, and Abstraction in particular, to the totality of twentieth-century life: the disintegration of social forms, the shocks of modern war, the abandonment of established faiths, the effort to match knowledge with comprehension. No period in history has called forth so many testaments and manifestos by groups of artists anxious to declare themselves to the world. Liberated, spontaneous art, which was supposed to be able to speak for itself, seemed to need as much justification and explanation as a political programme. (Braque was suspicious of this procedure: 'To define a thing', he said, 'is to substitute the definition for the thing itself.') In the end we have to look on such art not as an interpretation of ideas, but as ideas in their own right, expressed in paint.

As in other forms of modern communication, the medium is the message. For instance, the Futurist Manifesto, published in 1910, asserted that the modern notion of truth had nothing to do with conventional ideas of form and colour. A portrait must not be a likeness, and to paint a human figure the artist must render the whole of the surrounding atmosphere: in technical terms a well-nigh impossible feat. 'Who can still believe in the opacity of bodies,' demanded the Manifesto, 'since our sharpened and multiplied sensitivity has already penetrated the obscure manifestations of the medium?' From now on, 'we shall put the spectator in the centre of the picture.' As for the time-honoured idea of Man as the centre of the universe, his sufferings were of no more concern to the Futurists than the sufferings of an electric light bulb, 'which, with spasmodic jerks, shrieks aloud the most heart-rending expression of colour'. This is not a metaphor: the colour *is* the shriek.

Such an abstraction becomes possible in painting once the spectator – 'in the centre of the picture' – is part of the event. This idea has been acceptable ever since the end of the Great War, which for many European artists, writers and intellectuals was an experience so awesome as to turn them away from naturalism in all its forms. In 1919, Mondrian wrote that life was becoming 'more and more abstract. . . Modern man exhibits a changed consciousness: today, every expression of his life has a different aspect, an aspect more positively abstract.' So, inevitably, with art: as a pure representation of men's minds it would henceforth express itself in an 'aesthetically purified, that is to say abstract, form'.

This concept has held Abstract painters together, through numerous permutations of those early ideas, into recent times. To the American painter Robert Motherwell,

Abstract art remains 'a form of mysticism', stripped bare so as to intensify its rhythms, spatial intervals, and colour structure. It could only have come into existence as a consequence of what he calls 'a profound, relentless, unquenchable need'. Willem de Kooning, a contemporary, has remarked that Abstraction is an emphasis on what is taken out of a picture, not what is left in. Most of the theorizing, as de Kooning acknowledged, has at last died away. But the first impulse was strong enough to dominate painting for half a century, because it sprang from the mind and spirit of the age.

The universality of the Abstract style, and its penetration beyond Europe, owed much to its multi-racial origins. It emerged almost simultaneously in Munich and Paris, the fruit of the northern European imagination no less than of the Mediterranean. Historically, its roots lie in Art Nouveau, which in various forms flourished throughout Europe and in the United States during the closing years of the nineteenth century. The Munich and Berlin Secessions, and the early Expressionist group Die Brücke (The Bridge), helped to make way for Der Blaue Reiter (Blue Rider), formed in Munich in 1911 by a group of artists in search of a new painterly language. Its earliest members were Franz Marc, Kandinsky, Klee and August Macke. It was Marc who, in a succession of quasi-poetic statements, expressed the mystical and romantic elements that lay behind the group's ideas. He wrote that art 'is the bridge into the spirit world . . . the necromancy of the human race'. The art to come, he prophesied, would be 'the concretion in form of a scientific invention. . . It is deep and weighty enough to bring about the greatest re-shaping of form which the world has yet experienced.'

Klee held similar high-minded views, but filtered them through an essentially Gothic imagination. His world is peopled with mathematical imps, geometric goblins, gnomic cells, and germs. He went even further than Marc in his empathy with the animal world. 'I seek a distant point at the origins of creation,' he wrote, 'and there I use a kind of formula for man, animal, plant, earth, fire, water, air, and all encircling forces at once.' With such a faith it is not surprising if Klee's abstractions, though often beautiful, assume ectoplasmic forms issuing from a spooky world which looks as if it is being viewed through a microscope. Macke, a kindred spirit, wrote in the group's almanac that 'Man stands in a cross-fire of impressions from things in Nature. He responds to everything, even as he produces his art.' Macke was the first of the group to discover Orphism, or Orphic Cubism, which was Apollinaire's term for the dazzlingly chromatic art of the French painter Robert Delaunay, an exhibitor with the Blaue Reiter, and his Russian-born wife, Sonia (Plates 9 and 22). This marked a break with Cubism into a more aesthetically 'pure' style of painting which at once appealed to the incandescent imaginations of Marc and Klee.

The founder-figure of Abstract painting in Germany is Kandinsky, who from the year 1910 pressed his non-figurative creativity to the limit. A founder of the Munich group, he returned to Russia two years later, and after the war resumed his career there under the influence of the Suprematists – the circle of painters, headed by Kasimir Malevich, for whom the Russian Revolution seemed to usher in an entirely new artistic style based on logic and technology. From 1921 at the Bauhaus, Kandinsky developed geometric abstractions which have exerted an influence into modern times (Plate 17).

Kandinsky's eyes were opened to the non-representational dimension, he recalled later, when he entered his studio at dusk one day and found he did not recognize one of his own paintings. It was standing upside down, and in the half-light he saw it only as extraordinarily beautiful, 'glowing with an inner radiance'. It led him to the belief, affirmed in numerous statements and articles in later years, that abstract forms have an inner life no less than realistic forms. Abstraction and realism were thus both opposite and equal to one another, different aspects of a single truth.

By 1927 Malevich was claiming that Suprematism had enabled art to come into its own, by which he meant that it had attained its 'pure, unapplied form'. Non-objective feeling, which the Abstract painters believed in, opened the way to nothing less than 'a genuine world order'. A new philosophy of life now existed which recognized the non-objective nature of the world and was no longer concerned with 'providing illustrations of the history of manners'. The Suprematists' symbols were the square, the triangle and the circle, which they acknowledged as the oldest shapes in history, reaching back to cave art. At first Malevich eschewed colour, the painter's essential element, in pursuit of 'real forms' (Plate 11). He went on to achieve spatial effects by the juxtaposition of carefully chosen shades.

His was the method which inspired some of the best work of another Russian-born artist, El Lissitsky, whose daring and original architectural designs were based on his theory of the *Proun* (a mnemonic for The New Art), which he defined as 'a station for changing trains from architecture to painting' (Plate 13). In a drawing by Lissitsky a line tends to take a number of contrary directions, defying the eye to determine which one represents its true purpose. The resultant sense of movement is exactly what Lissitsky set out to achieve. He directly influenced such northern painters as Jean Arp, Theo van Doesburg, Laszlo Moholy-Nagy and Kurt Schwitters, and was one of the outriders of the Dada movement. The smothering of the Constructivist movement by the Soviet régime soon after Lissitsky's death anticipated similar action in Germany by the Nazis, who in 1936 applied the jackboot to what they called 'degenerate art'.

In the Netherlands, the group of artists who called themselves De Stijl (The Style) set themselves the task of creating social and cultural integration by harmonizing art and everyday life in a common brotherhood. Mondrian, their 'high priest', spoke of a time when 'we shall no longer need paintings, for we shall live in the midst of realized art'. The group's magazine, edited by the passionately articulate van Doesburg, became a powerful voice in this utopian enterprise until the mid-twenties, when Mondrian left, feeling it had now deserted its true cause. He continued at the centre of the Abstract movement, retaining both his vision and his artistic energy into old age. To him more than to any of his contemporaries we owe the use of Abstraction in commercial art and design, where his rectilinear sense of balance, rhythm and proportion has left its imprint on a generation of graphic designers (Plate 15).

Mondrian, van Doesburg and Kandinsky all spent time in Paris, along with the self-exiled Czech painter, Frank Kupka, who exhibited a strictly non-representational work at the Salon d'Automne as early as 1912. Delaunay's *Disques*, in the same year, introduced the new concept of Orphism, a departure from Cubism in which he was accompanied by Fernand Léger, Picabia and Marcel Duchamp. Jacques Villon, a brother of Delaunay, became spokesman for the influential Section d'Or, or Golden Mean, the theory of harmonious geometric proportion. Contributors to their first exhibition included Gris, friend and compatriot of Picasso, who found his way to Abstraction through what he called 'the art of synthesis, of deduction'.

Those were the days of the École de Paris, so called for the intellectual fertility that enabled a polyglot population of artists to pursue their ideas without constraint. After 1918 the ex-Cubists and the De Stijl painters co-existed in separate groups, until in 1931 an association was formed which united virtually all Abstract painters under a single label: Abstraction-Creation. The numerous 'isms' came together – Constructivism, Neo-Plasticism and Expressionism among them – in exhibitions where Mondrian, van Doesburg, Lissitsky, Arp, Kupka, Alberto Magnelli and scores of like-minded painters showed their works under one roof. Some of them took long side-glances at Surrealism, successor to Dada, as it came capering by. In 1938 Kandinsky consigned all such 'isms' to history in an article in *XXᵉ Siècle*, adding that the future lay with Concrete art, which was now flourishing under the banner of Abstraction-Creation.

What lay ahead, however, was a more violent turn than the theorists imagined.

With the onset of World War II, painters in the United States began to expunge the intellectual and lyrical elements in Abstract painting. This was the beginning of Abstract Expressionism, later to be known as Action painting, and in France as *art informel* or *Tachisme*. Abstraction now meant the direct and often violent expression of the painter's involuntary moods and impulses, straight on to the canvas: the modern counterpart, as the American painter Barnett Newman called it, of 'the primitive art impulse'. He explained: 'Here in America, some of us, free from the weight of European culture, are finding the answer by completely denying that art has any concern with the problem of beauty and where to find it... We are creating images whose reality is self-evident, devoid of the props and crutches that evoke associations with outmoded images.'

The New York School took over from Paris, and the names of hitherto unknown American painters – de Kooning, Jackson Pollock, Clyfford Still, Arshile Gorky, Franz Kline, Robert Motherwell – became synonymous with the avant-garde. In Paris, Hans Hartung, an early follower of Kandinsky and Klee, led a movement towards a European alternative, *autre art*, on the same principles of impromptu confrontation with the canvas, in company with another German-born artist, Pierre Soulages, and Nicholas de Staël. The northern painters formed an Abstract Expressionist group called Cobra, consisting of a Dane, Asger Jorn, a Belgian, Corneille, and the Dutch painter Karel Appel. It flourished until the late 1950s, by which time Abstract Expressionism in America was approaching its end. As the turmoil subsided, the work of the more meditative members of the New York School – Rothko, Still, Tobey – was a reminder of the poetic, intellectual and spiritual values with which Abstract painters had been grappling for half a century. But as the New York School passed from the scene it could look back on a dozen fruitful years – as long, and as short, a time as earlier groups had served in the cause of bringing art into the same strange planes as the modern mind.

The Plates

Plate 1. GEORGES BRAQUE (1882–1963): *Woman Reading.* 1911. Oil on canvas, 130 × 81 cm. Paris, Private Collection.

Braque's association with Picasso during the formative years of Cubism resulted in a close affinity of styles: his *Woman Reading* is strikingly similar in both tone and composition to Picasso's work of the same year, notably the *Woman with a Guitar at the Piano* (Prague, National Gallery) and variants on similar themes. The two artists worked, as Braque put it, 'like climbers roped together on a mountain', though in fact they seem to have arrived at this particular summit by separate routes. Braque's own painterly values are already evident, despite such innovations as lettering, imitation wood-grains and the use of pasted paper *(papier collé)*, which emphasize by their literalness the hallucinatory nature of the subject as a whole. Cubism, which passed through various forms, is the true progenitor of Abstract painting in the twentieth century.

Plate 2. FERNAND LEGER (1881–1955): *The Wedding.* 1910–11. Oil on canvas, 255 × 206 cm. Paris, Musée d'Art Moderne.

Léger's early contact with the Cubist painters is evident in this work, though his subject is treated in a highly personal, geometrically explicit way: the crowd lining the street take their fill of the bride. Léger became a member of the Section d'Or group of artists, which included Metzinger and Gleizer, the two main theorists of Synthetic Cubism (successor to Analytical Cubism), Picabia, Duchamp, Kupka and La Fresnaye. These painters drew less upon the strictly objective values of Picasso and Braque than on the example of Cézanne, whose posthumous exhibition in 1907 stands as a landmark in modern art. Léger's theory of aesthetics is summed up in his statement that: 'Beauty is everywhere, in the arrangement of your pots and pans, on the walls of your kitchen, more perhaps than in your eighteenth-century salon or in the official museum.'

Plate 3. FRANCIS PICABIA (1879–1953): *Udnie.* 1913. Oil on canvas. Paris, Musée d'Art Moderne.

A founder member with Duchamp of the Section d'Or, Picabia painted *Udnie* as he was emerging from his short-lived Cubist period. In the year it was painted Guillaume Apollinaire wrote of him: 'Each of Picabia's pictures has a definite existence, the limits of which are set by the title. These pictures are so far from *a priori* abstractions that the painter can tell you the story of each one of them.' *Udnie* is such a picture: choreographic in inspiration, it is a remembrance of a ballerina whom the artist met while crossing the Atlantic in 1913. The painting is otherwise known as 'American Girl' or 'The Dance'.

Plate 4. FRANK KUPKA (1871–1957): *Disks.* 1911–12. Oil on canvas, 49·5 × 65·1 cm. Paris, Musée d'Art Moderne.

Kupka, a Czech living in Paris, exhibited with the Section d'Or and at the Salon d'Automne in 1912 and ranks as one of the earliest non-representational painters. His series of *Newton-Disques*, based on the conception of 'Orphic' Cubism (Apollinaire's term for the looser manner practised by Delaunay) marks the beginning of pure Abstraction. Kupka's vertical compositions of this date forsake objective forms for what he called 'invented elements'. His work is characterized by the influence of decorative themes from his native Bohemia.

Plate 5. AUGUST MACKE (1887–1914): *Garden on Lake Thun.* 1913. Oil on canvas. Bonn, Städtische Kunstsammlungen.

A German-born painter who worked with Delaunay in Paris, Macke belongs in the circle of Kandinsky and Marc, whom he followed into the Blaue Reiter group.

His declared aim was 'to dissolve the spatial energies of colour', and it is as a colourist that he most influenced his companions, not least Klee. Macke shared with Marc and Klee a feeling of identification with life-forces outside the Self, forms that are the expression of mysterious powers. 'The senses are the bridge from the incomprehensible to the comprehensible. To look at plants and animals is to feel their mystery. To understand the language of forms is to come closer to the mystery. To create forms is to live.'

Plate 6. MARCEL DUCHAMP (1887–1968): *Nude Descending a Staircase, No. 2.* 1912. Oil on canvas, 147·5 × 89 cm. Philadelphia, Museum of Art (Louise and Walter Arensberg Collection).

Duchamp said of this famous picture, originally exhibited at the Section d'Or exhibition of 1912, that his interest in painting it was 'closer to the Cubists' interest in decomposing forms than to the Futurists' interest in suggesting movement'. Nevertheless, it succeeds in an extraordinary way in depicting a woman walking downstairs, the figure being represented by a sequence of planes and curves which slant across the surface in a convincing, almost cinematic, simulation of movement. Dotted lines denote the body's undulations, and cartoonist's swirls mark the rhythmic downward tread.

Plate 7. PABLO PICASSO (1881–1973): *Still Life with Gas Burner.* 1912–13. 68·5 × 55·5 cm. London, Roland Penrose Collection.

Picasso was too individual an artist to allow himself to be attached to any school or group, even one of his own making. Others might see in Cubism the beginnings of Abstract art, but Picasso refused to believe in it as a separate concept, readily introducing shapes, forms, and even materials, from everyday life. Ideas and feelings, he said, should be permanently imprisoned in a picture. 'They are an integral part of it, even though their presence may no longer be discernible.' The progress of other painters towards Abstraction owed much to Picasso's brilliant simplifications and to his reorganization of shapes and space. 'You can eliminate every aspect of realism, and what is left is an idea which is just as real as the object that has disappeared.'

Plate 8. FRANZ MARC (1880–1916): *The Bewitched Mill.* 1913. Oil on canvas. Chicago, Art Institute.

Born in Munich, Marc discovered Impressionism in Paris, where he undertook intensive studies of animals. These studies provided themes that contributed to his personal vision of an indivisible world. He learned from the Cubists, and formed a friendship with Delaunay which advanced his use of colour. His work contains an almost mystical romanticism, intensified by vibrant blues, yellows and reds. He told Macke: 'Blue is the male principle, severe and spiritual. Yellow is the female principle, gentle, cheerful and sensual. Red is matter, brutal and heavy.' He was killed on active service near Verdun.

Plate 9. SONIA DELAUNAY-TERK (b. 1885): *Electric Prisms.* 1914. Oil on canvas. Paris, Musée d'Art Moderne.

Sonia Delaunay-Terk was born in the Ukraine, and married Robert Delaunay in 1910. She is noted for her use of 'simultaneous contrasts', and also for her designs for stage costumes (she worked on Diaghilev's production of the opera *Cléopâtre*), which made an impact in the world of fashion. She continued to develop the notion of 'simultaneity' in her later work, notably during her membership of the Abstraction-Creation group in the thirties. Her big mural for the 1937 World's Fair in Paris was much admired. *Electric Prisms* generates its power by the use of bright, assertive colours which nevertheless make a harmonious as well as dynamic whole.

Plate 10. JUAN GRIS (1887–1927): *Still Life with Pears.* 1913. Oil on canvas, 60 × 73 cm. Meriden, Connecticut, Mr and Mrs Burton Tremaine.

An early association in Paris with his compatriot Picasso, and with Braque, led Gris into Cubism. His work is distinctively rhythmic and richly coloured, its structure

firmer than either Picasso's or Braque's at this period. Nor does he disguise the objects introduced into his compositions: they continue to serve the same function as in their own world. In 1921 Gris wrote: 'I work with the elements of the intellect, with the imagination. I try to make concrete that which is abstract. . . I compose with abstractions (colours) and make my adjustments when these assume the form of objects.'

Plate 11. KASIMIR MALEVICH (1878–1935): *Supreme.* Before 1915. Oil on canvas, 66 × 97·2 cm. Amsterdam, Stedelijk Museum.

Malevich, born in Russia, was influenced first by Fauvism and subsequently by the Cubists, whose ideas he took back to Russia after a stay in Paris. His own contribution was to develop a non-objective style of painting, dubbed Suprematism: an abandonment of natural objects in favour of new symbols, particularly the square, the triangle and the circle, with which to render 'the primacy of pure sensation'. An example is his series *White on White* (1918), in which only faint brush strokes distinguish one white square from another on the same surface. In Malevich's words, the Suprematist 'does not observe, and he does not touch – he feels'.

Plate 12. THEO VAN DOESBURG (1883–1931): *Composition 1 × (9).* 1917. 116 × 106 cm. The Hague, Gemeente Museum.

A self-taught Dutch painter, van Doesburg was an early associate of Mondrian, with whom he started De Stijl and the magazine of the same name, dedicated to the total rejection of visual reality. Instead, its adherents maintained that the source of art was a 'universal consciousness' out of which would come 'universal harmony'. Colour was reduced in both key and range, and composition became a linear exercise based on squares and cubes, emphatically structured in right-angles. 'Strip nature of all its forms,' wrote van Doesburg, 'and what you have left is style.'

Plate 13. EL LISSITSKY (1890–1941): *Proun.* About 1920. Oil on canvas, 57·8 × 47·6 cm. Birmingham, Michigan, Mr and Mrs H. L. Winston.

An engineer by training, Lissitsky was fired by the Suprematist ideology as expounded by Malevich to produce what he called *Prouns*, abstract designs for spatial constructions. The squares and planes of Malevich's paintings are given a further spatial dimension in Lissitsky's work, providing 'a station for changing trains from architecture to painting'. The deliberate ambiguity of his forms and the daring plausibility of his constructions made him one of the most important of the post-revolutionary Russian artists.

Plate 14. KURT SCHWITTERS (1887–1948): *Hair-Navel Picture.* 1920. Collage, 89 × 71 cm. London, Lords Gallery.

Schwitters was a founder of the Dada movement in Hanover, and one of the most consistently inventive painters in that company. No other artist carried to such extremes the use of scraps, ephemera, rubbish and discarded objects from the everyday world as he did in pursuit of *Merz*, his personal synonym for physical, emotional or artistic expression. (An inscription on this painting says, *Merz ist nicht Dada.*) He was a master of collage, and of the 'controlled accident'. Materials, he said, are not to be used logically in their objective relationships, but 'only within the logic of a work of art'.

Plate 15. PIET MONDRIAN (1872–1944): *Composition.* 1922. Oil on canvas. Ossington, New York, Mr and Mrs Herbert M. Rothschild.

After a notable period as an Expressionist painter in his native Holland, Mondrian absorbed the Cubist experience before rejecting it for 'not accepting the logical consequences of its own discoveries'. A founder of De Stijl, he pursued his personal notion of pictorial structures as intrinsically real abstractions: in other words the idea that the act of painting is itself a reality, needing no facts, forms or figurative elements in support. Indeed, 'particularities of form obscure pure reality'. In Mondrian's neo-plastic paintings the elements are held in a state of tension achieved

by strong lines, colours and rectangles that give the illusion, not the substance, of form.

Plate 16. LASZLO MOHOLY-NAGY (1895–1946): *AII.* 1924. Oil on canvas, 113 × 134 cm. New York, Solomon R. Guggenheim Museum.

Moholy-Nagy, a Hungarian, came under the influence of Malevich and Lissitsky, and in 1923 joined the Bauhaus staff as an artistic director. He shared the views held by Mondrian and the De Stijl painters, and was particularly successful in his use of processes from the world of technology, which he used with a care and a knowledge based on first-hand experience in the Bauhaus laboratory and workshops. He later moved into 'photograms' and to stage and cinema design, where he applied the principles that give direction and consistency to his art.

Plate 17. WASSILY KANDINSKY (1866–1944): *In Blue.* 1925. Düsseldorf, Kunstsammlung Nordrhein-Westfalen.

Both as a theorist and as an innovator, Kandinsky stands near the summit of the Abstract achievement. Born in Russia, he moved to Munich in 1896, and later met Marc, Klee and Macke, with whom he formed the Blaue Reiter group. He taught at the Bauhaus from 1922, and held to his own view of Abstract art for the rest of his life. This is contained in the three categories which he defined in his own work: direct impressions of an 'exterior' nature; unconscious expressions of an 'interior' nature; and pictures arising from long periods of work and gestation, called 'compositions'. His true originality, perhaps, is in his simulation of space as coloured forms, seemingly born of the pre-conscious imagination. His use of brush or pencil as an involuntary extension of himself can be said to have anticipated Action painting.

Plate 18. JOAN MIRO (b. 1893): *Figure in a White Rectangle.* 1928. Grenoble, Musée des Beaux-Arts.

Miró belongs with his fellow Spaniards, Picasso, Gris and Picabia, as a brilliant technician and activist of the modern movement in Paris. Images and themes from his native Catalonia found a place in his Surrealist paintings of the twenties, in many of which, and also in Abstract work like this example, black and white are equated with such fundamentals as life and death, day and night. This is painting 'born in a state of hallucination, provoked by some shock or other, objective or subjective, for which I am entirely irresponsible'. While his treatment of the human figure becomes increasingly bestial and nightmarish in his middle years, in his later paintings he takes more account of the material he works with: 'It supplies the shock which suggests the form, just as cracks in a wall suggested shapes to Leonardo.'

Plate 19. PAUL KLEE (1879–1940): *Palace from Four Sides.* 1933. Private Collection.

This painting dates from the year in which Klee, labelled a 'degenerate' artist by the Nazis, left Germany to live in his native Switzerland. By this time he was one of the most distinguished of European painters, and his work combined elements of Expressionism, Cubism and Surrealism in a wholly individual style. The dream-like innocence of Klee's imagination, often laced with wit, drew on images from the natural world and from primitive art. His advice to students at the Bauhaus, where he taught for twenty years, was to 'dig deep and lay bare'. For him, the idea always came first. 'Since infinity has no definite beginning, but like a circle may start anywhere, the Idea may be regarded as primary. In the beginning was the Word. . .'

Plate 20. MAX ERNST (b. 1891): *Edge of a Forest.* 1926. Bonn, Städtische Kunstsammlungen.

Ernst's imagination has been haunted by images from his early life, among them the 'enchantment and terror' of the forests to which his father took him as a child in Germany. He joined the Blaue Reiter group, served in the Great War, and subsequently, as a Dadaist, dubbed himself 'Dadamax'. He was a pioneer of Surrealism and of the technique of *frottage* – laying sheets of paper on grained wood

or floorboards and rubbing them with black lead before incorporating them into drawings. This led to his using other materials in the same way, including leaves and sacking (visible in the foreground of this painting). The artist, he said, 'assists as a spectator, indifferent or passionate, at the birth of his work'.

Plate 21. JACQUES VILLON (1875–1963): *Amro.* 1931. Oil on canvas, 46 × 55 cm. Paris, Musée d'Art Moderne.

A brother of Marcel Duchamp, whose scientific approach to painting he shared, Villon helped to organize the first Section d'Or exhibition in 1912, at which time he was painting in the Analytical Cubist style. He turned to Abstract painting in the 1920s, usually in a low-toned palette of greys and browns. In the thirties his colours brightened, recalling his early Fauvist days. His reputation, particularly as a colourist, has advanced rapidly in recent years.

Plate 22. ROBERT DELAUNAY (1885–1941): *Rhythm 579.* 1934. Oil on canvas, 145 × 113 cm. Paris, Mme S. Delaunay.

Delaunay is the French painter who most influenced the Blaue Reiter group, thus forming a link between the northern European artists and the School of Paris that helped to advance the cause of Abstract art. He achieved his first success with his *Disques* and 'circular cosmic forms', which were essentially exercises in rhythmical colour effects. His discovery that light and colour are indivisible took him into work that Apollinaire proclaimed as 'Orphic' Cubism. This was the idea that painting was a matter of colour manipulated in the same way (as Delaunay put it) as the notes in a fugue, 'in coloured phrases, contrapuntally'. He was sufficient of a purist to reject the Synthetic Cubists' use of material objects in a painting, and went his own way, tackling problems by means of interacting colour, much in the manner of musical composition: harmonious colours make for slow movements, discordant ones for speed.

Plate 23. NICHOLAS DE STAEL (1914–55): *Composition.* 1948. Oil on canvas, 116 × 81 cm. Paris, Galerie Jacques Dubourg.

De Staël was born in St. Petersburg, exiled to Poland with his family, and sent to school in Brussels. He travelled for five years before settling in Paris, where he was befriended by Braque. He achieved recognition in the United States before making much impression in Paris, but his strongly structured Abstracts have since become widely admired. The present example is in the subdued tones of the work he did in the 1940s. His later paintings were more representational, introducing elements from the material world. De Staël committed suicide at the age of 41.

Plate 24. ALBERTO MAGNELLI (b. 1888): *Sonorous Border.* 1938. Oil on canvas, 97 × 146 cm. Paris, Galerie de France.

Born in Florence, Magnelli joined the Futurists and Cubists in Paris, and came under the influence of Delaunay and Kandinsky. His work subsequently became largely figurative, but he returned to Abstract painting in the early 1930s with a series of 'splintered stones' compositions that led him into the Abstraction-Creation group. His later work is severely geometrical, and related to still-life. He has written: 'In its forms, the naturally invented subject expresses a myth; by "invented" I mean invented by the artist who cleaves his way through nature. Thus, the Abstract picture bears traces of signals that have come from far away.'

Plate 25. ARSHILE GORKY (1904–48): *Golden Brown Painting.* 1943. 108 × 140 cm. New York, Sidney Janis Gallery.

Gorky, who was born in Turkish Armenia, emigrated with his parents to the United States as a child, studied painting in New York, and in 1935 contributed to an exhibition of Abstract painting in America at the Whitney Museum. His style of painting, which owed much to his close study of Picasso, to his circle of expatriate European artists, and to Miró, was a foretaste of Abstract Expressionism, though he never received the cachet of the Action painters themselves. His studio was burned down in 1946, and two years later he took his own life.

Plate 26. MARK TOBEY (b. 1890): *Pattern of Conflict.* 1944. Gouache on board, 33·7 × 48·3 cm. Meriden, Connecticut, Mr and Mrs Burton Tremaine.

Largely self-taught, Tobey has drawn on his travels to the East and his interest in oriental cultures to suggest conjunctions of painterly styles in which calligraphy, Red Indian art and pure Abstraction have all found a place. His aim has been to 'smash' form by eliminating perspective: not by Abstract Expressionist methods, but by a reflective delicacy that reveals his lifelong involvement with oriental philosophy and religion.

Plate 27. HANS HARTUNG (b. 1904): *T.1947.25.* 1947. Oil on canvas, 48·5 × 73 cm. Paris, Private Collection.

Born in Dresden, Hartung has spent most of his career outside Germany. He was influenced in turn by the Expressionists and by Kandinsky and Klee, and after World War II (in which he served in the Foreign Legion and lost a leg) he became a central figure in the École de Paris, along with Wols and other exponents of *art autre*, the European response to Action painting. His mastery of dark tones, and his command of seemingly intuitive shapes and swirls, enable him to emphasize an intrinsic patch of pure colour with telling effect.

Plate 28. JACKSON POLLOCK (1912–56): *Eyes in the Heat II.* 1947. Oil on canvas, 61 × 52 cm. Paris, Galerie Berggruen.

The most prominent American painter of his generation, Pollock typified the quest for an American form of Expressionism, and the aggressive idealism generally associated with the post-war culture of the United States. His 'drip' technique (originally invented by Max Ernst) opened the way for brilliant random effects, and has been widely copied by less painterly artists. Pollock's intricate and sophisticated Action paintings helped to give the New York School a prestige which in the 1950s overshadowed that of Paris. Pollock said of his method: 'I am not aware what I'm doing. . . I have no fears about making changes, because the painting has a life of its own. It is only when I lose contact with the painting that the result is a mess.'

Plate 29. WOLS (Wolfgang Schulze, 1913–51): *Gouache.* 1949. 21·5 × 15 cm. Paris, John Craven Collection.

Originally a student of ethnology at Frankfurt, Wols spent a brief period at the Bauhaus before moving to Paris, where he attached himself to Miró, Ernst and their circle. He was interned at the outbreak of World War II, but was released in 1940 and spent the following years in poverty in southern France, drawing incessantly. In 1945 he returned to Paris, but refused to exhibit. The devotees of *art autre* turned to his withdrawn, intuitional gouaches and watercolours with enthusiasm.

Plate 30. SERGE POLIAKOFF (1906–69): *Gouache.* 1948. 65 × 50 cm. Paris, M. S. Collection.

A close friend of the Delaunays and of De Staël, Poliakoff, who was born in Russia, at first supported himself in Paris by playing the guitar in bars and cabarets. He achieved his first one-man show only in 1945, and has since been acknowledged both as a masterly, though unacademic, colourist, and as a lithographer. Abstract art, he said, is 'an ensemble that penetrates into the Cosmos, overflowing the framework and creating its own world'.

Plate 31. MARK ROTHKO (1903–70): *No.8.* 1952. Oil on canvas, 204·4 × 172·7 cm. Meriden, Connecticut, Mr and Mrs Burton Tremaine.

The distinctive rectangles of shimmering colour, seemingly adrift in space, that are a mark of Rothko's best-known work, date from 1947. His earlier work is Expressionist, shading into Surrealism in paintings akin to those of his fellow Americans, Arshile Gorky and William Baziotes. Rothko searched for the irreducible image, and perhaps came closest to it in these subtly luminous blocks of colour. He said: 'I am not interested in relationships of colour or form or anything else. . .

I am interested only in expressing the basic human emotions – tragedy, ecstasy, doom.'

Plate 32. GINO SEVERINI (1883–1966): *Pastel drawing.* 1949. 26·7 × 44·5 cm. Paris, M. S. Collection.

Severini belonged to the generation that included his compatriot Modigliani, whom he met on moving to Paris from Rome in 1906, and the circle of Picasso, Braque and Matisse. He was a signatory to the Futurist Manifesto of 1910, and two years later he painted a Futurist masterpiece in the *Dynamic Hieroglyphic of the Bal Tabarin* (New York, Museum of Modern Art). He went from Futurism to a variant of Cubism, often based on large, complementary areas of silvery-grey. He was at various times a follower of Picasso, even to the adoption of a neo-classical style; but his essential quality was a decorative one, which he sometimes displayed on an impressive scale.

Plate 33. BEN NICHOLSON (b. 1894): *Kerrowe.* 1953. 28·6 × 41·9 cm. Paris, M. S. Collection.

Nicholson is the most important British painter to have made Abstraction the basis of his work. However, his abstractions have also extended to geometrical relief, adding a second dimension, as in this work of 1953. Influenced in his early years by artists such as Picasso, Gris and Mondrian, he has nevertheless succeeded in his own terms in demonstrating the ability of Abstract painting to exert a force outside the frame, to exist as an 'object' rather than simply as a picture. His work also contains representational elements traditional in the work of northern painters, so that it has never been wholly cryptic.

Plate 34. VICTOR VASARELY (b. 1908): *Sirius II.* 1954. Oil on canvas, 30·2 × 20 cm. Paris, Galerie Denise René.

Vasarely's contribution to the modern movement has been his revival of the geometric style of Abstract art, of which this painting is an example. His most typical work is based on the optical disturbance of vertical and horizontal lines by wavering transverse or circular shapes, that bring the structural elements into ambiguous relationships with one another. His example was followed soon afterwards by the partisans of Op Art, for whom Vasarely's work, and that of the American painter Josef Albers, provided a launching point. Describing his own sculptures, Vasarely wrote in 1958 of their 'architectonic, abstract art form, a sort of universal folklore', readily adaptable to the techniques of modern construction.

Plate 35. JEAN (HANS) ARP (1887–1966): *Morning Geometry.* 1955. 63·5 × 55 cm. Paris, Private Collection.

The Concrete element in much of Arp's later work, as in this example, reflects his achievements in sculpture. Though closely associated in his youth with the Blaue Reiter group, and with Dada, he moved from Abstract painting through reliefs, constructions and collage to sculpture, preferring the term Concrete as applied to his work in general. In this he is identified with Brancusi, though of the two his works had the greater sense of organic form. 'The absurd resemblance to something else' that he recognized in his creations prompted him to give his works titles unimagined at the outset. He wrote: 'Wherever Concrete art enters, melancholy goes out, dragging its grey valises crammed full of black sighs.'

Plate 36. ROBERT MOTHERWELL (b. 1915): *I Love You IIa.* 1955. Oil on canvas, 182·8 × 137·2 cm. New York, Sidney Janis Gallery.

After studying philosophy at Stanford University, California, Motherwell was persuaded to take up painting some years later while at Columbia University, New York. He was offered his first one-man show by Peggy Guggenheim in 1944. With Baziotes, Newman and Rothko he founded Subjects of the Artist on East 8th Street, New York, which became a forum for experimental artists and writers. To Motherwell, Abstract art is 'an effort to close the void that modern men feel. Its abstraction is its emphasis.'

Plate 37. ANDRE MASSON (b. 1896): *Genesis I.* 1958. 162 × 130 cm. Paris, Louis Leiris Collection.

In the 1920s, Masson joined with his friend Miró in opposition to Synthetic Cubism, a fashion antithetical to his own conviction (born of his experiences in the Great War) that 'the great prostitute is Reason'. He reacted by what he later called 'a frenzied abandon to automatism', under the banner of Surrealism. In 1929, however, he disengaged and went his own way, painting with 'automatic' gestures of his hand – the first exploration towards Abstract Expressionism. He called Automatism 'the investigation of the powers of the unconscious', with nature and the elements providing the subjects.

Plate 38. FRANZ KLINE (1910–62): Untitled. 1957. Düsseldorf, Kunstsammlung Nordrhein-Westfalen.

An American painter who studied in Boston and London before settling in New York in 1939, Kline became noted for free, vigorously executed Abstracts, including some which consist of bold black strokes on plain white. In such paintings, the domineering lines of black emphasize the spatial values of the uncovered, 'negative' areas of white. Some, such as *Chief* (New York, Metropolitan Museum of Art), have a specific or associative title, which is described in slashing strokes appropriate to the dynamism of the subject.

Plate 39. KAREL APPEL (b. 1921): *Big Animal Devours Little Animal.* 1959. Oil on canvas, 162 × 130 cm. Zürich, Galerie Charles Lienhard.

Born in Amsterdam, Appel was a founder of the Cobra group, named after the cities its first members came from: Copenhagen, Brussels, Amsterdam. They shared an interest in folk themes and primitive art, and in free, unpremeditated expression in paint. Appel can sometimes be seen to have applied paint straight from the tube, as in this example, in a way that gives it a separate presence from surrounding paint applied by conventional means.

Plate 40. ALFRED MANESSIER (b. 1911): *The Sixth Hour.* 1957–8. Oil on canvas, 250 × 322 cm. Paris, Galerie de France.

A Surrealist in the 1930s, Manessier was subsequently drawn to the Orphic Cubism of the Delaunays: the use of colour in its most natural application, as a distillation of light. This, and a preoccupation with medieval church windows, has led him to use colour in a religious context, both in his later paintings and in his mastery of stained glass. The *Sixth Hour* exemplifies this aspect of his work: early sunlight, fragmented in blood-red patterns, against the sinister symbols of crucifixion.

Plate 41. FRITZ HUNDERTWASSER (b. 1928): *Sun and Spiraloid Epoch over the Red Sea.* 1960. Hamburg, Siegfried Pappe Collection.

The richly ornamented spiral compositions for which Hundertwasser is noted owe much to his early admiration of Klimt and Schiele, to the Baroque tradition of his native Austria, and to his later explorations of Persian and Indian art. As a colourist, too, he has been deeply influenced by oriental sources no less than by the painters of the Vienna Secession, whose opulent colours, including gold and silver, make frequent appearances in his work.

Plate 42. ERNST WILHELM NAY (b. 1902): *Receding Ochre.* 1959. Oil on canvas, 100 × 81 cm. Cologne, C. Scheibler Collection.

Nay studied in his native city, Berlin, before moving on to Paris, Rome, and eventually, at the invitation of Munch, to Norway. Originally a Realist, he has since turned to Abstract painting, a decision influenced by his Zen faith. His works revolve around elemental themes, infused with a personal view of the universal truths that give them form and meaning. His is an essentially northern Romantic view, which keeps him closer to the mainstream than much of his work might suggest.

Plate 43. PIERRE SOULAGES (b. 1919): *Painting.* 1960. 130 × 97 cm. Paris, Private Collection.

Soulages has established himself among the European artists who embraced a form of Abstract Expressionism, by developing an individual form of composition based on black strokes applied in broad, lattice-like areas on a coloured ground. The cohesion of a typical Soulages composition comes from the rhythmic relationship of the elegant black strokes to each other, holding the forms together transversely as well as vertically and horizontally.

Plate 44. WILLEM DE KOONING (b. 1904): *Villa Borghese.* 1960. Oil on canvas, 200 × 175 cm. Meriden, Connecticut, Mr and Mrs Burton Tremaine.

De Kooning was born in Holland, and entered on his career as an Abstract painter when he came under the influence of Kandinsky soon after arriving in the United States in 1926. His relationship with Arshile Gorky helped to harden his ambitions as an artist, but only in post-war years has he emerged as a consistently Abstract stylist. His black-and-white compositions and the residual figurative elements in much of his work are characteristic. Though he belonged in the company of such American painters as Pollock, Rothko, Gottlieb and Still, he has refused to be labelled as a member of any movement: 'I do not need a movement. What was given to me I take for granted.'

Plate 45. CORNEILLE (Cornelius van Beverloo, b. 1922): *The Great Rock Wall.* 1961. Oil on canvas, 100 × 73 cm. Paris, Galerie Ariel.

A Belgian painter of Dutch descent, now living in Paris, Corneille was a founder of the Cobra group. He was influenced by both Picasso and Matisse in his early years, when he was a painter of landscapes in the Fauvist style. He went on to suggest forms seen as if from a height, and later turned to the surfaces of natural objects, particularly rocks and minerals – subjects which have been called 'themes born of matter itself'.

Plate 46. SAM FRANCIS (b. 1923): *Composition.* 1960. Oil on canvas, 65 × 81 cm. Paris, Galerie Jacques Dubourg.

A Japanese influence is apparent in much of Sam Francis's work after 1957 (he has lived in Tokyo), and particularly, as in this picture, in his use of the *haboku* or 'flung ink' style. He is known for his more lyrical contributions to Action painting, which have included paint applied with a sponge instead of a brush. Francis has been compared with the self-styled Minimalist painters, who aim at a total lack of personal involvement in both subject and method.

Plate 47. BRAM VAN VELDE (b. 1895): *Painting.* 1960. 129·5 × 162 cm. Paris, Henri Samuel Collection.

Van Velde, who was born in Holland, has worked in Germany, Paris and Geneva. After Expressionist beginnings, he turned in the late 1930s to a more Abstract style in still-life subjects. Since 1945 he has attracted notice with his 'collapsed' compositions (he never gives them specific titles), whose limpness is a deliberate contrivance. It once prompted Samuel Beckett to remark that van Velde is the first painter to admit that 'to be an artist means to fail as no-one else dares to fail'.

Plate 48. LEON POLK SMITH (b. 1906): *Prairie Blue.* 1960. Oil on canvas, 100 cm. in diameter. New York, Mr and Mrs Arthur Lejwa.

An attractive example of the Minimalist tendencies of recent American painting, in which, on large canvases, the subject-matter is reduced to coloured shapes arranged for their decorative value. Rothko (Plate 31) was an early exponent of this enlarged and simplified approach to Abstraction.

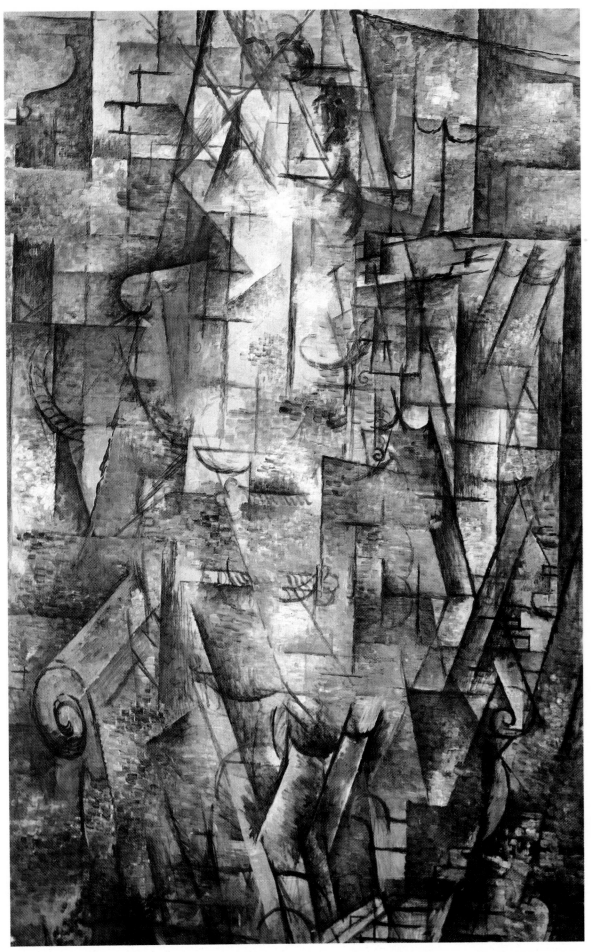

1. GEORGES BRAQUE (1882–1963): *Woman Reading*. 1911. Paris, Private Collection

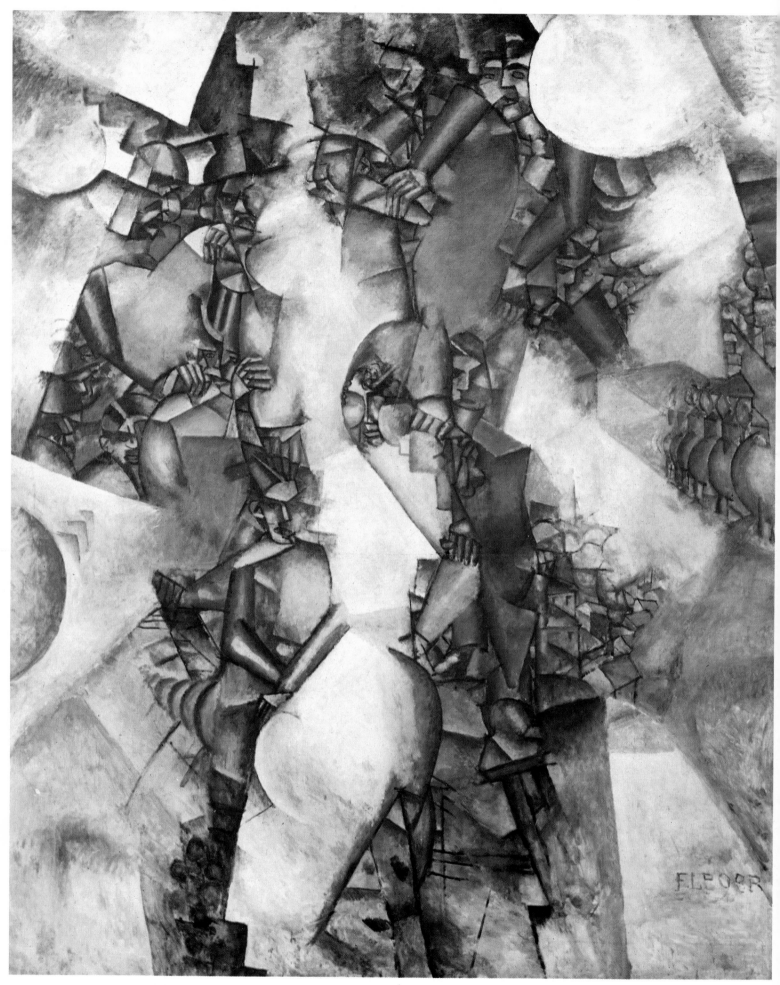

2. FERNAND LEGER (1881–1955): *The Wedding*. 1910–11. Paris, Musée d'Art Moderne

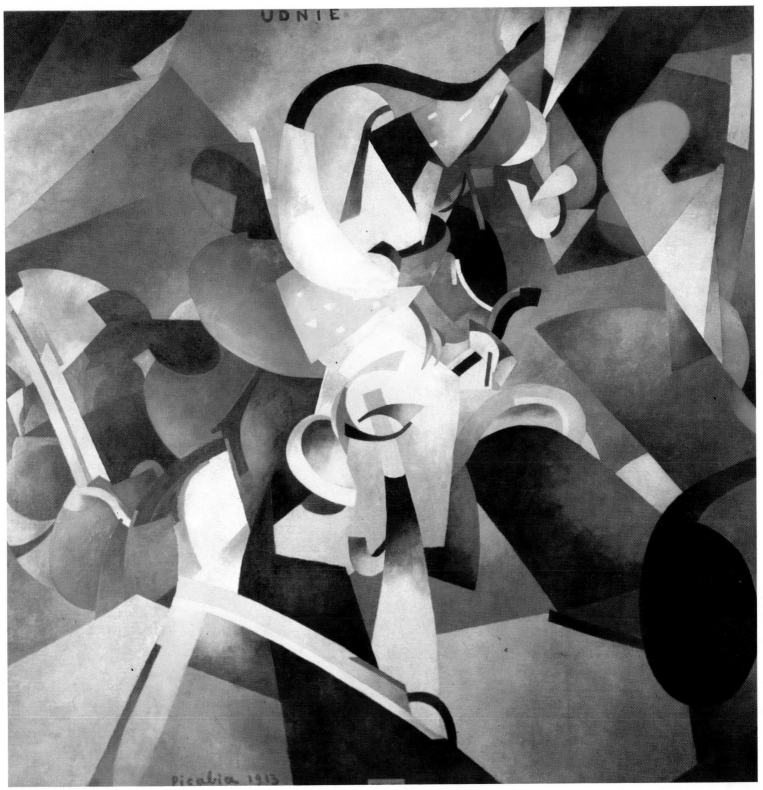

3. FRANCIS PICABIA (1879–1953): *Udnie.* 1913. Paris, Musée d'Art Moderne

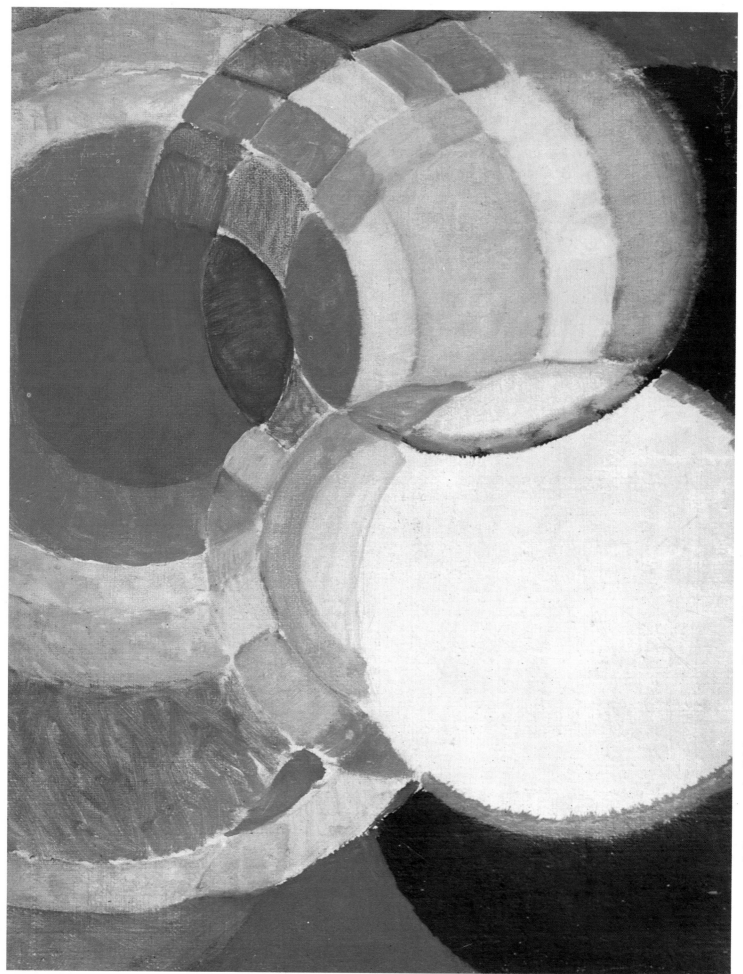

4. FRANK KUPKA (1871–1957): *Disks*. 1911–12. Paris, Musée d'Art Moderne

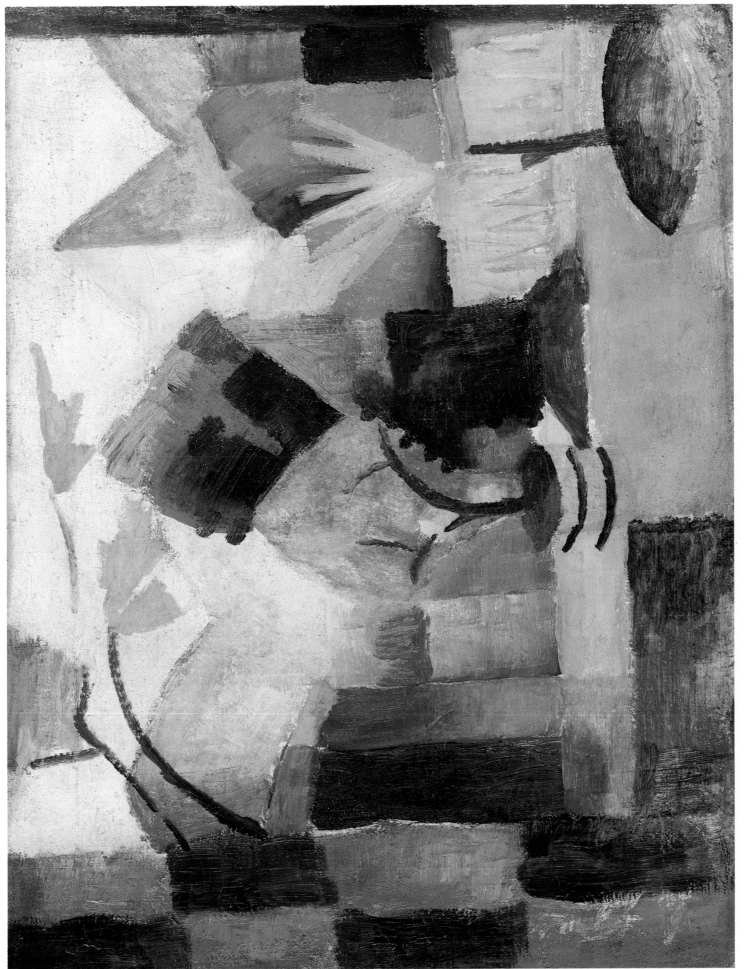

5. AUGUST MACKE (1887–1914) : *Garden on Lake Thun*. 1913. Bonn, Städtische Kustsammlungen

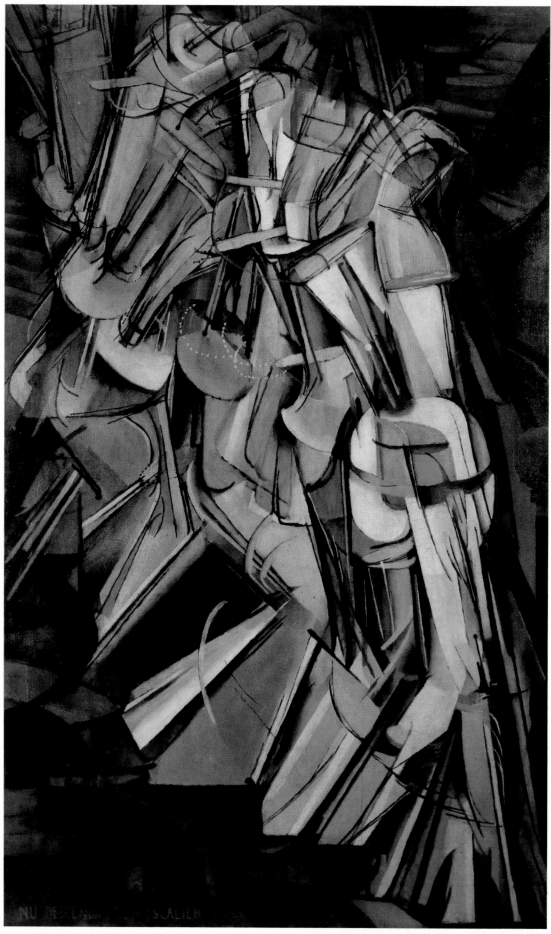

6. MARCEL DUCHAMP (1887–1968): *Nude Descending a Staircase, No.2.* 1912.
 Philadelphia, Museum of Art (Louise and Walter Arensberg Collection)

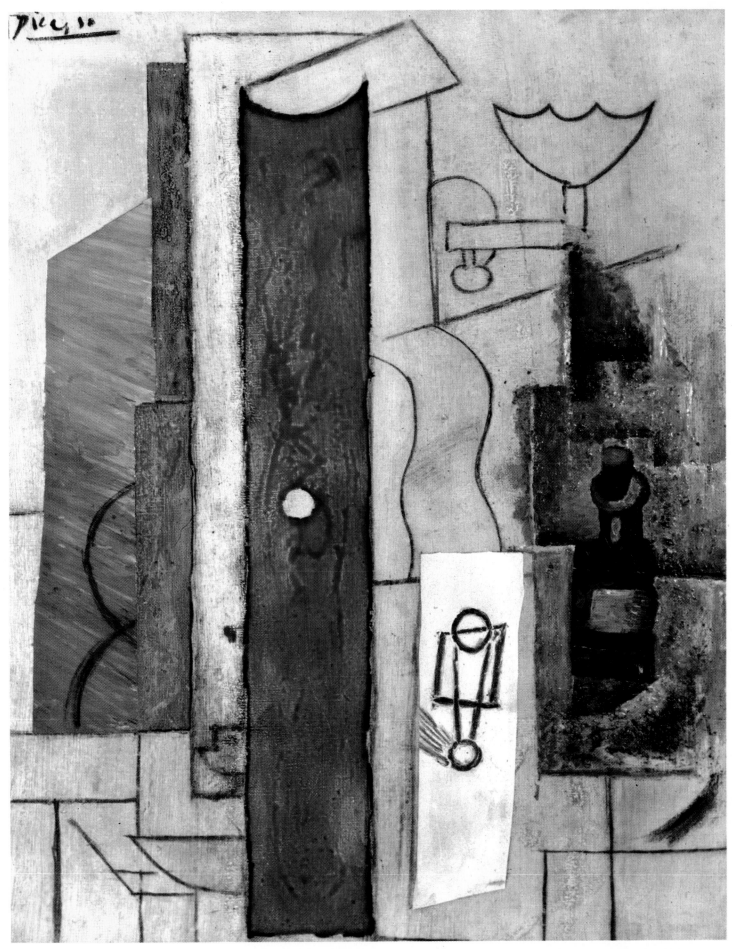

7. PABLO PICASSO (1881–1973): *Still Life with Gas Burner*. 1912–13. London, Roland Penrose Collection

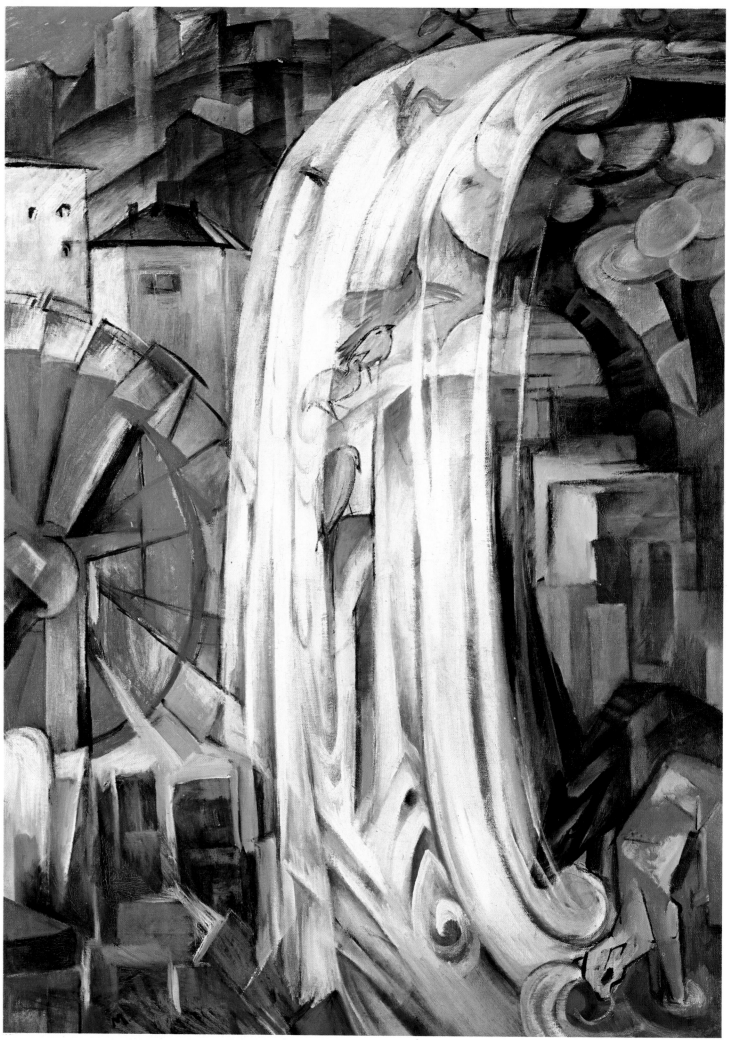

8. FRANZ MARC (1880–1916): *The Bewitched Mill*. 1913. Chicago, Art Institute

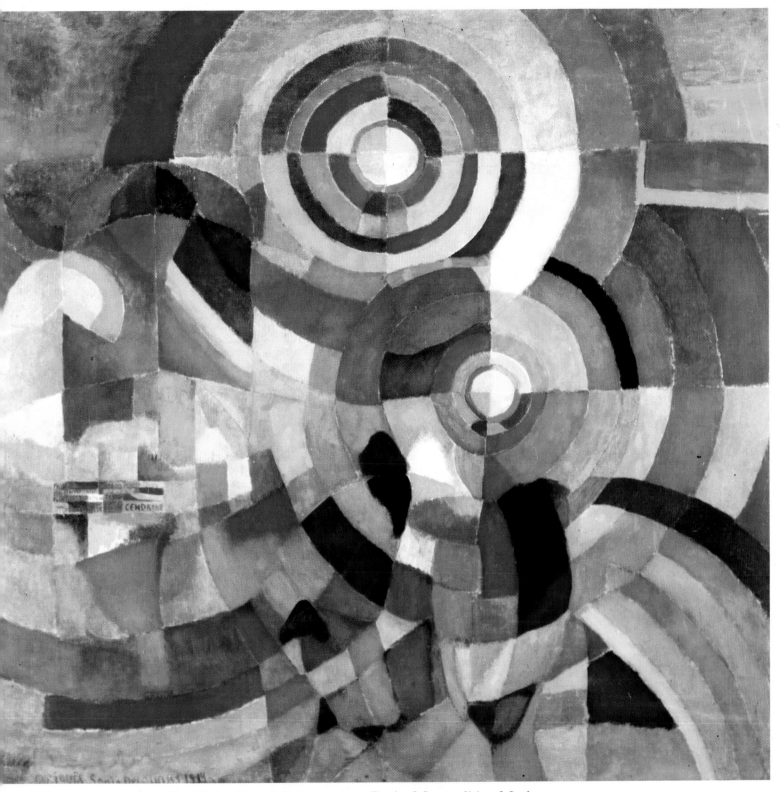

SONIA DELAUNAY-TERK (b.1885): *Electric Prisms.* 1914. Paris, Musée d'Art Moderne

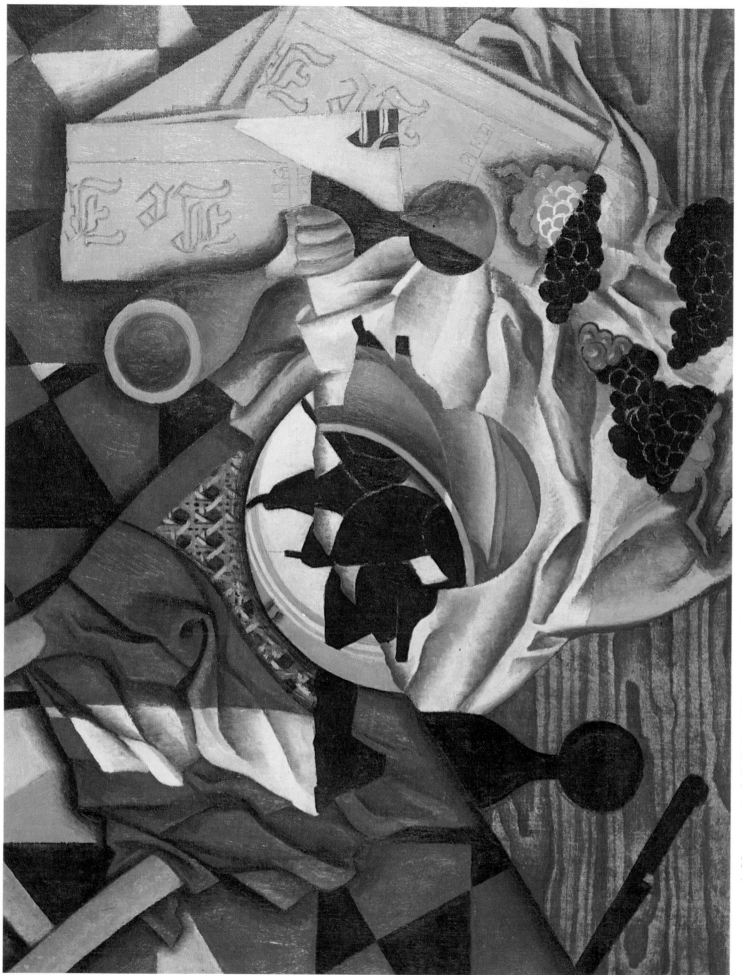

IO. JUAN GRIS (1887–1927): *Still Life with Pears*. 1913. Meriden, Connecticut, Mr and Mrs Burton Tremaine

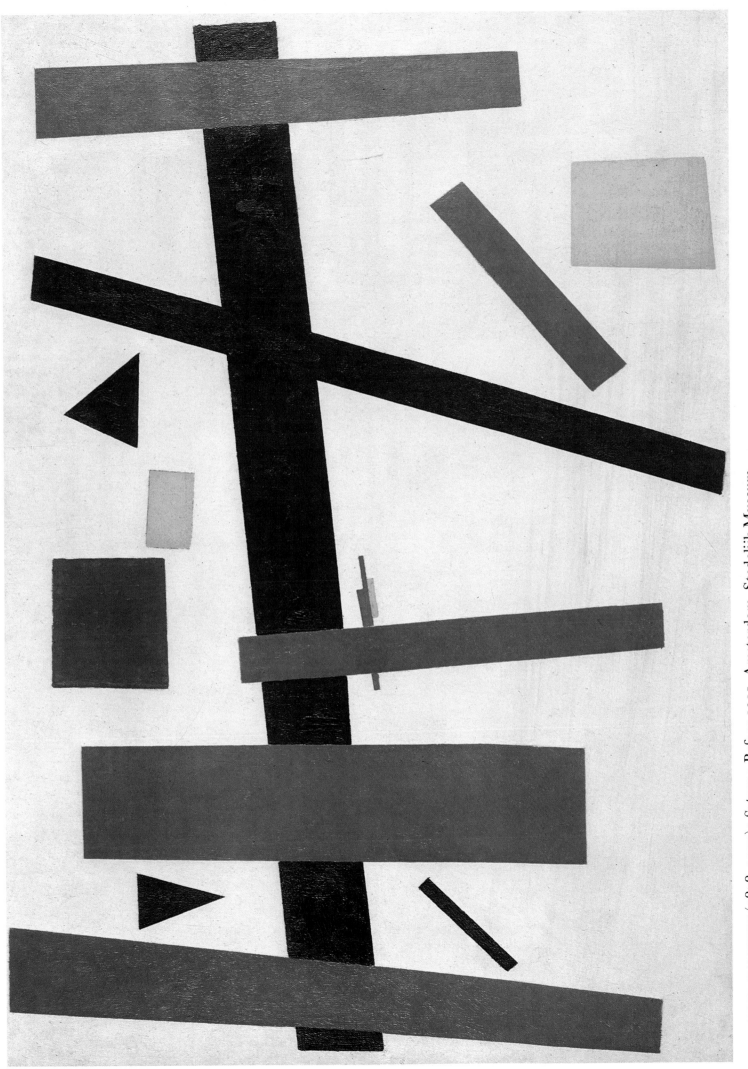

11. KASIMIR MALEVICH (1878–1935): *Supreme*. Before 1915. Amsterdam, Stedelijk Museum

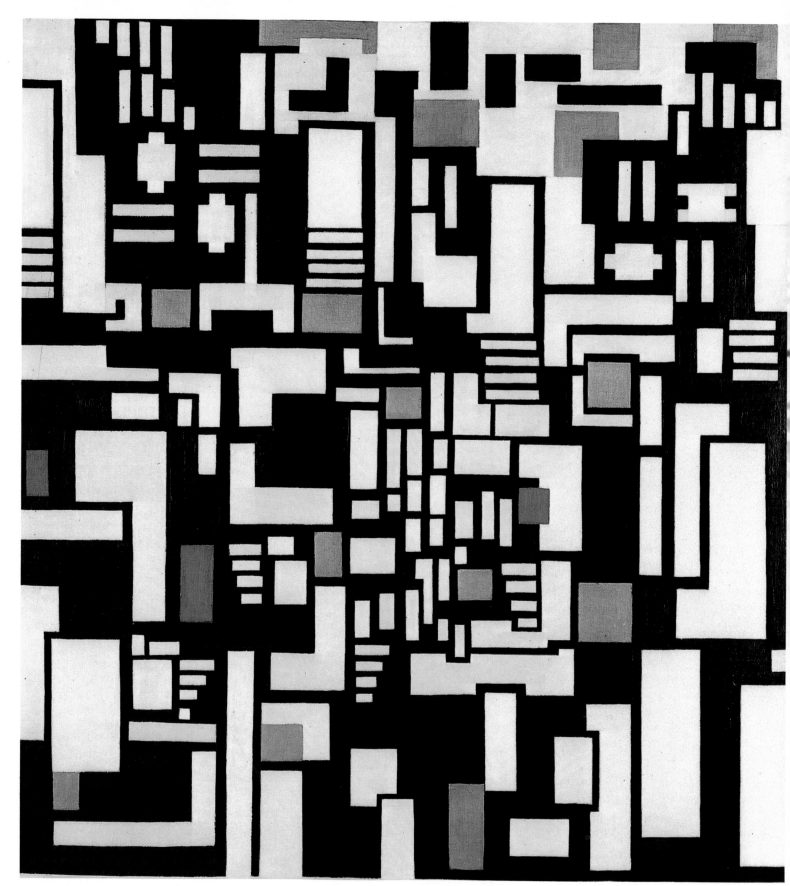

12. THEO VAN DOESBURG (1883–1931): *Composition I × (9).* 1917. The Hague, Gemeente Museum

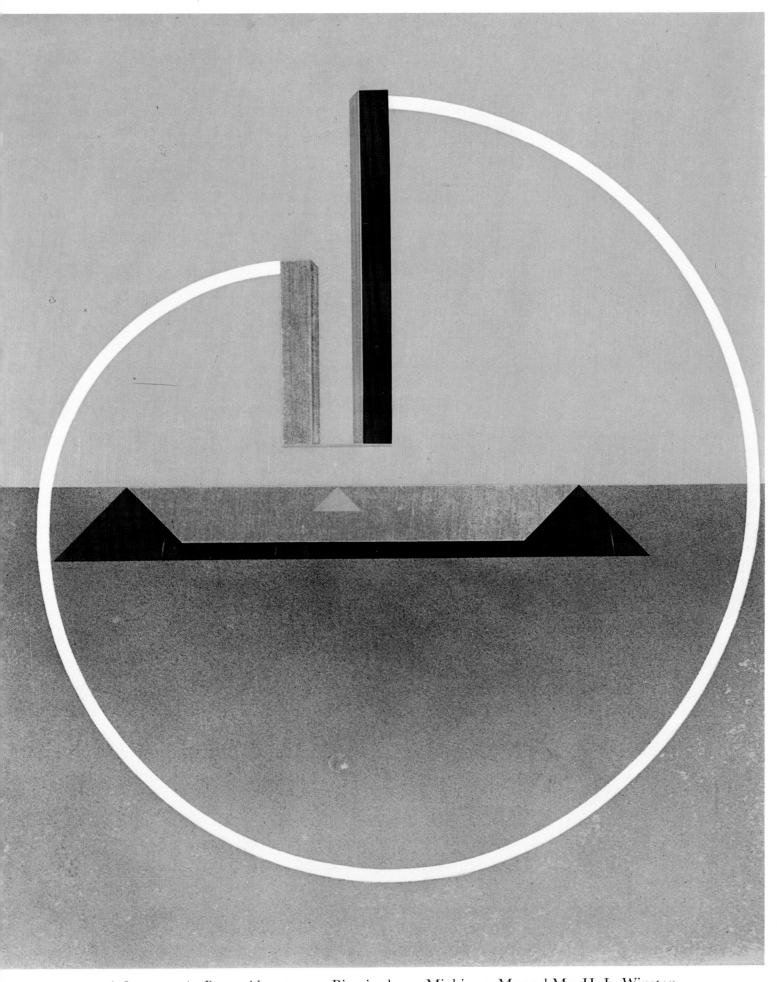

3. EL LISSITSKY (1890–1941): *Proun*. About 1920. Birmingham, Michigan, Mr and Mrs H. L. Winston

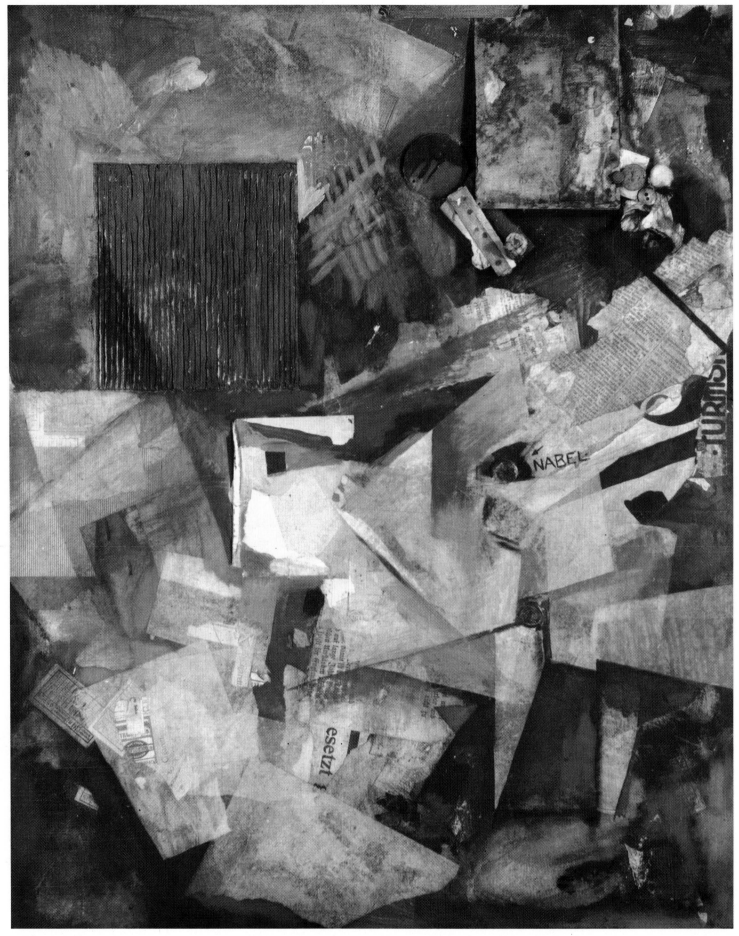

14. KURT SCHWITTERS (1887–1948): *Hair-Navel Picture*. 1920. London, Lords Gallery

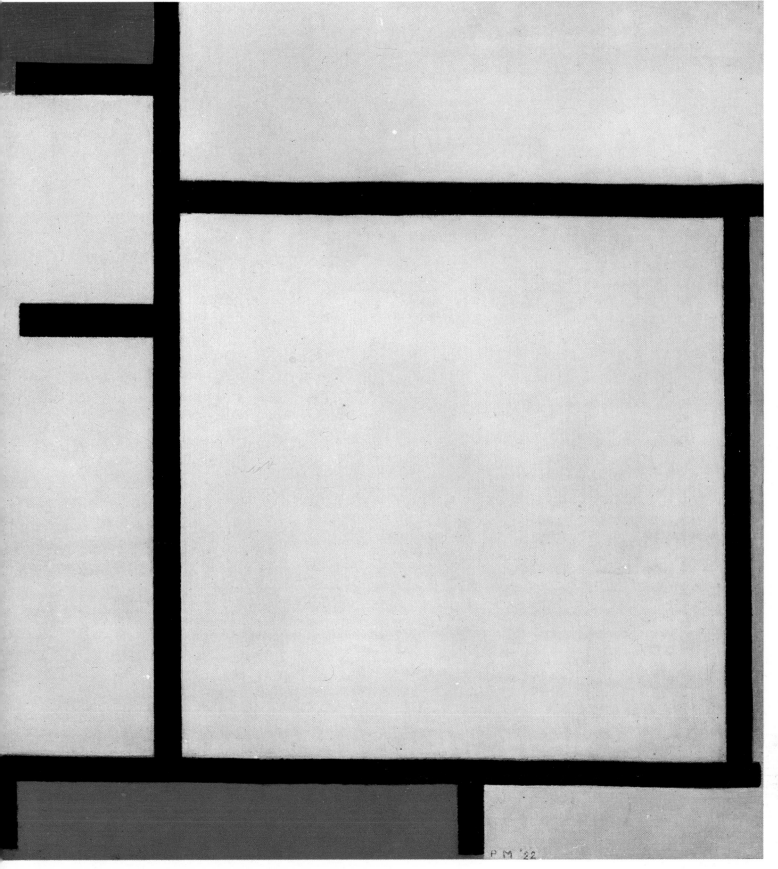

5. PIET MONDRIAN (1872–1944): *Composition*. 1922. Ossington, New York, Mr and Mrs Herbert M. Rothschild

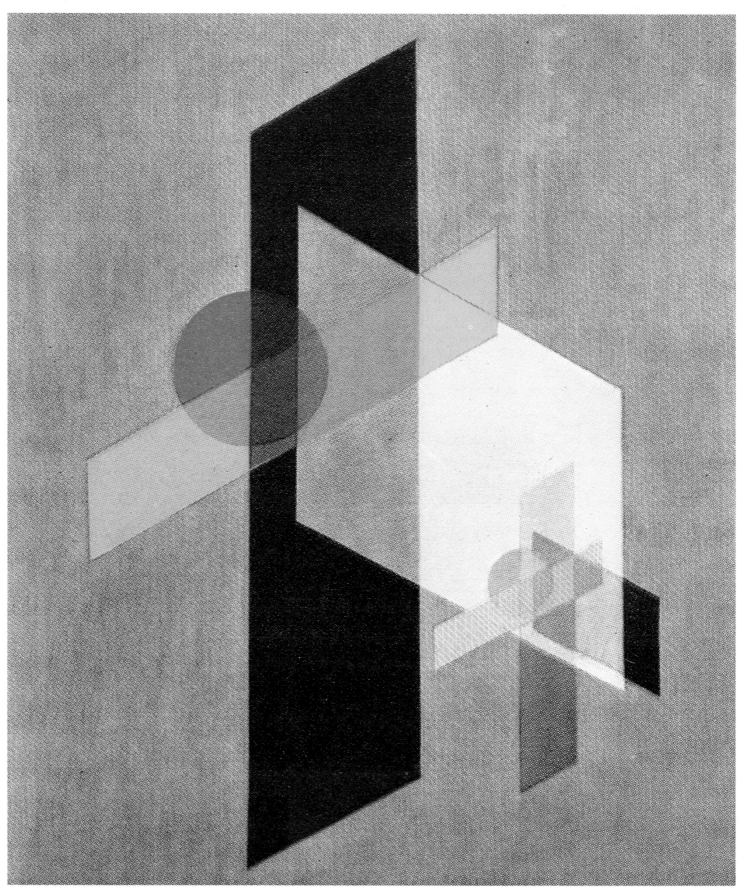

16. LASZLO MOHOLY-NAGY (1895–1945) : *AII*. 1924. New York, Solomon R. Guggenheim Museum

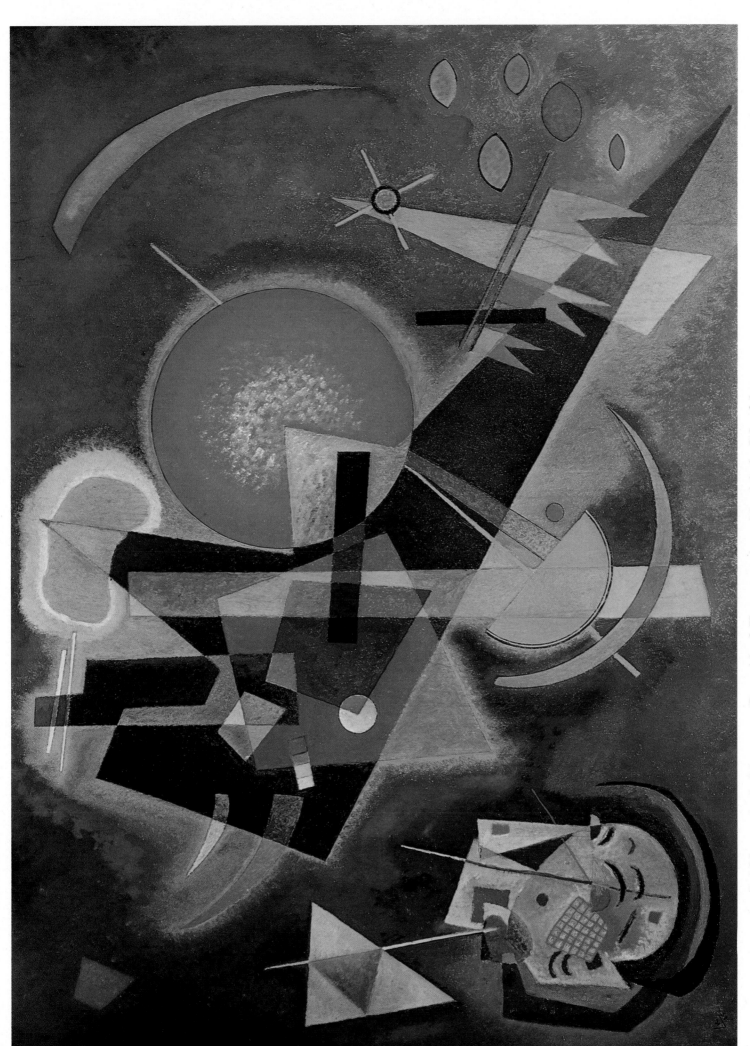

17. WASSILY KANDINSKY (1866–1944) : *In Blue.* 1925. Düsseldorf, Kustsammlung Nordrhein-Westfalen

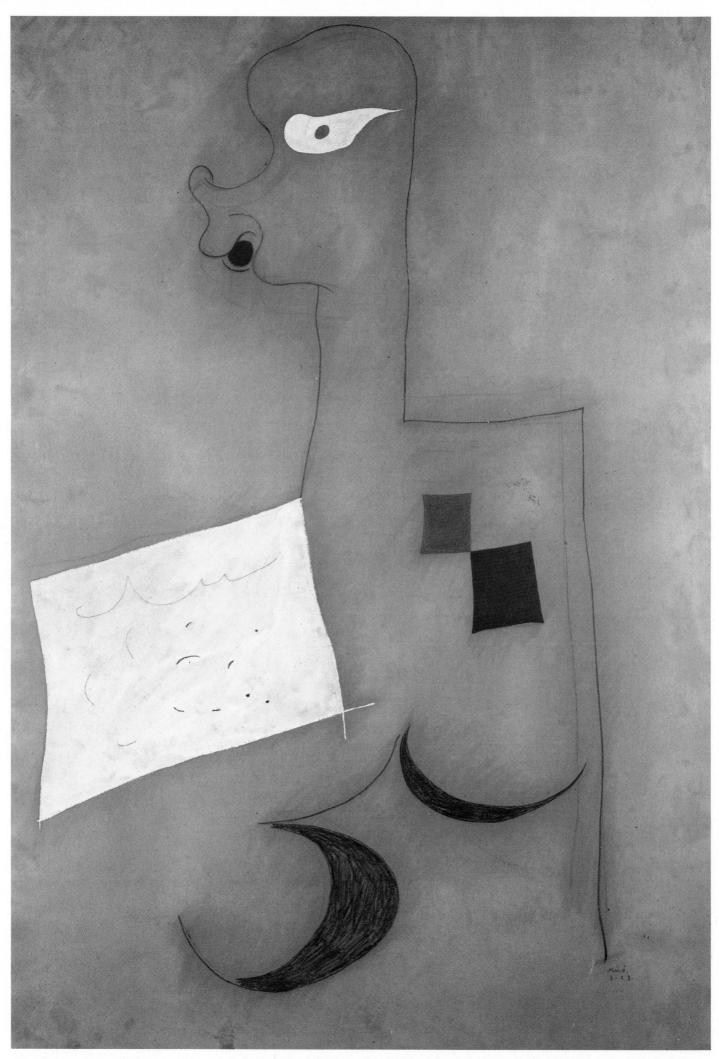

18. JOAN MIRO (b.1893): *Figure in a White Rectangle*. 1928. Grenoble, Musée des Beaux-Arts

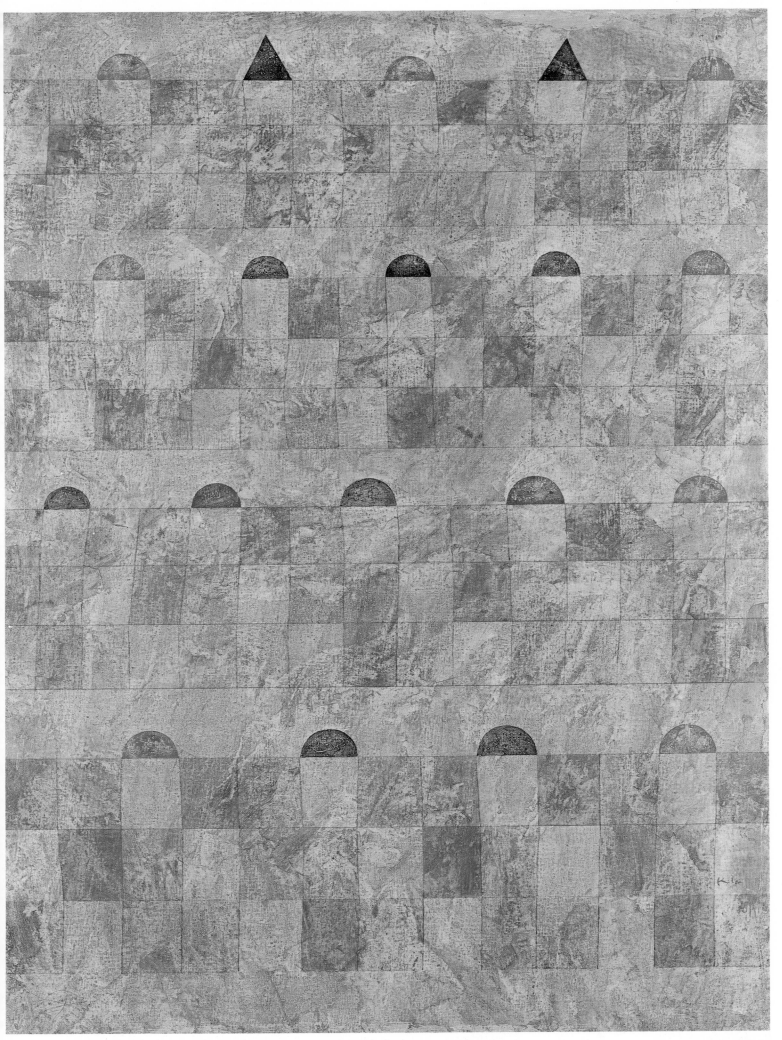

19. PAUL KLEE (1879–1940): *Palace from Four Sides.* 1933. Private Collection

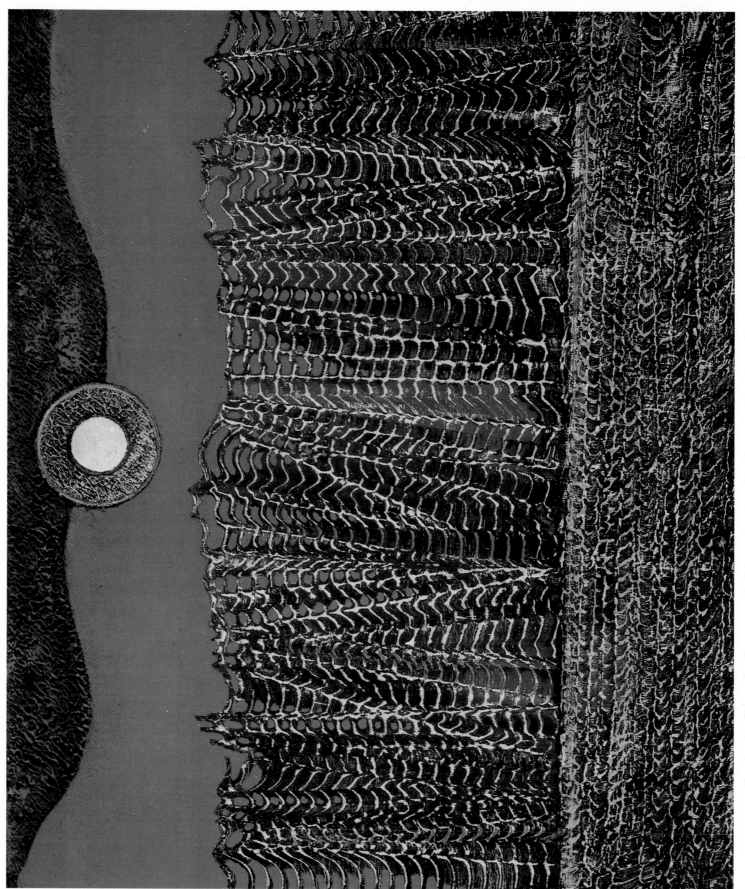

20. MAX ERNST (b.1891) : *Edge of a Forest.* 1926. Bonn, Städtische Kunstsammlungen

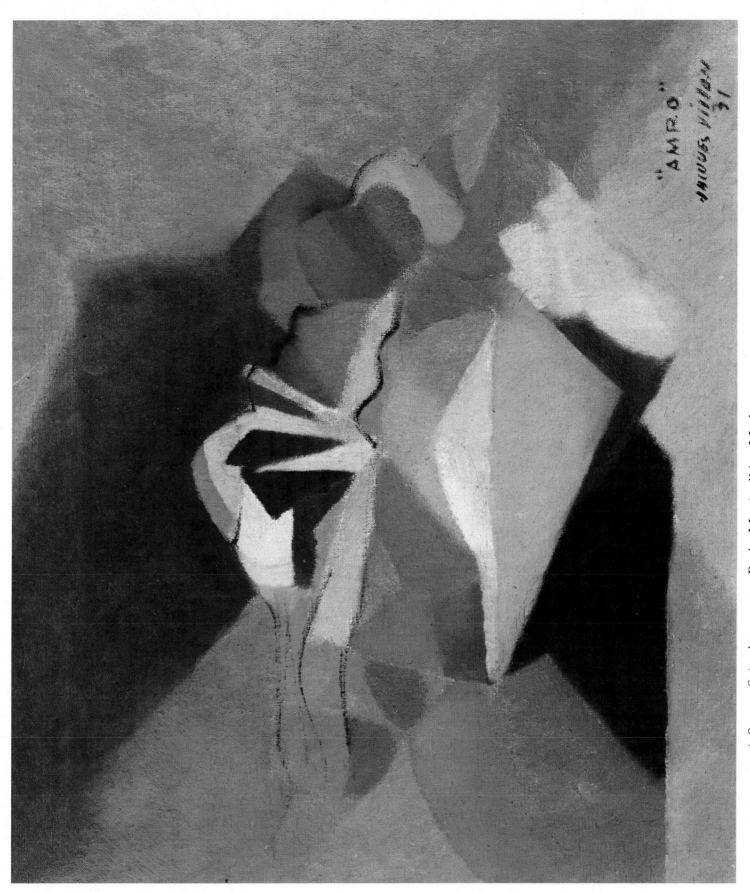

21. JACQUES VILLON (1875–1963) : *Amro*. 1931. Paris, Musée d'Art Moderne

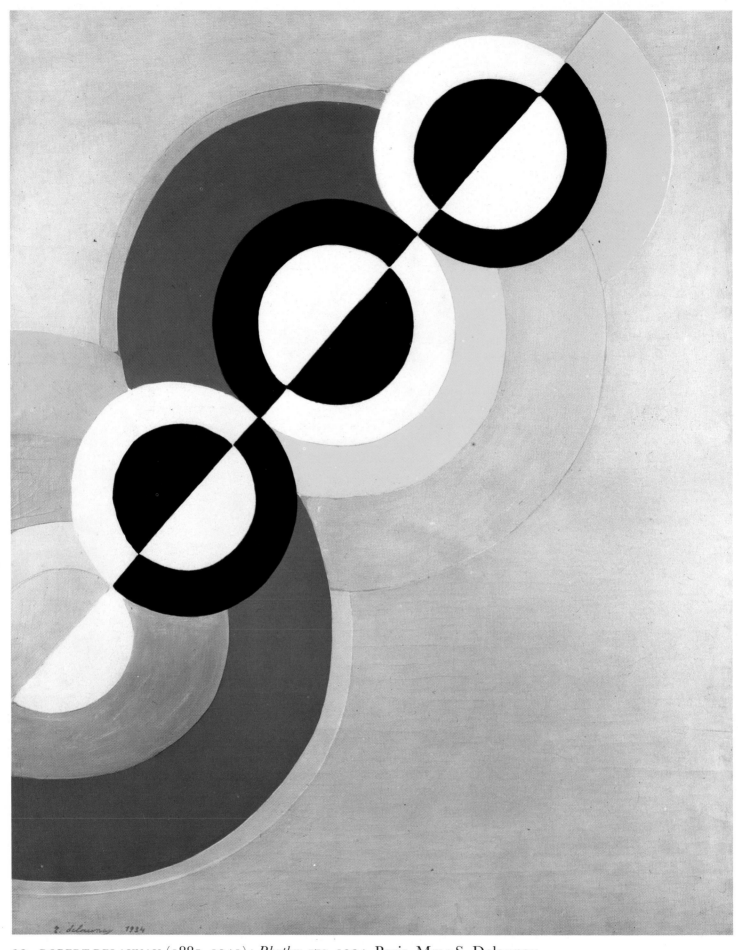

22. ROBERT DELAUNAY (1885–1941): *Rhythm 579*. 1934. Paris, Mme S. Delaunay

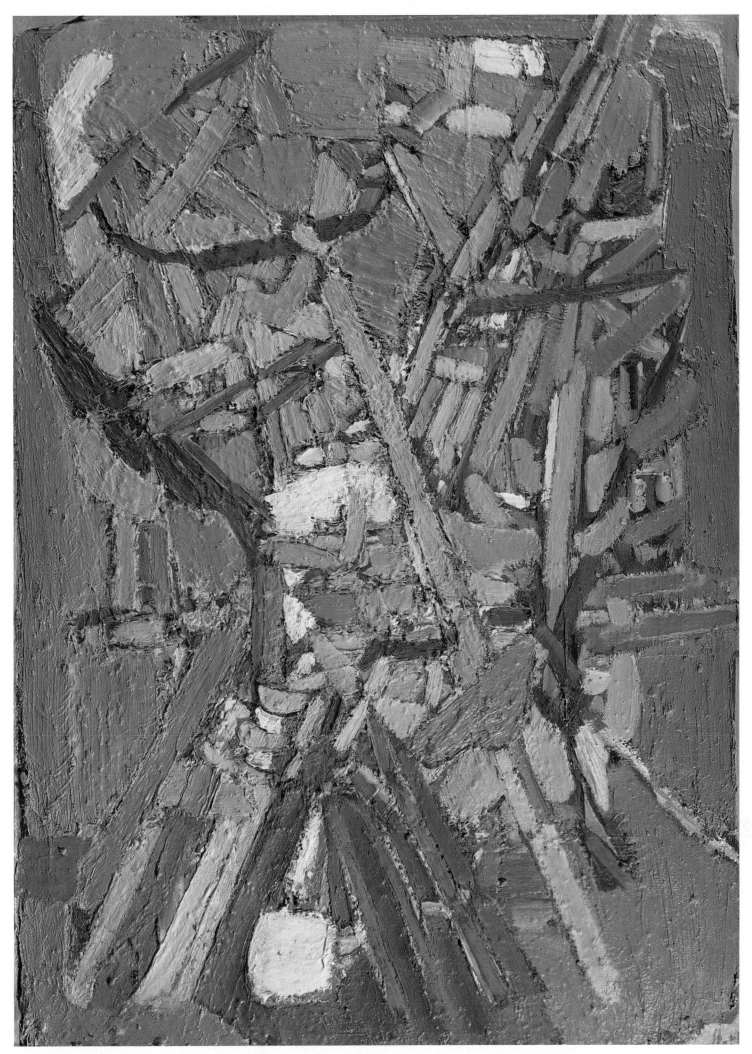

23. NICHOLAS DE STAEL (1914–55): *Composition*. 1948. Paris, Galerie Jacques Dubourg

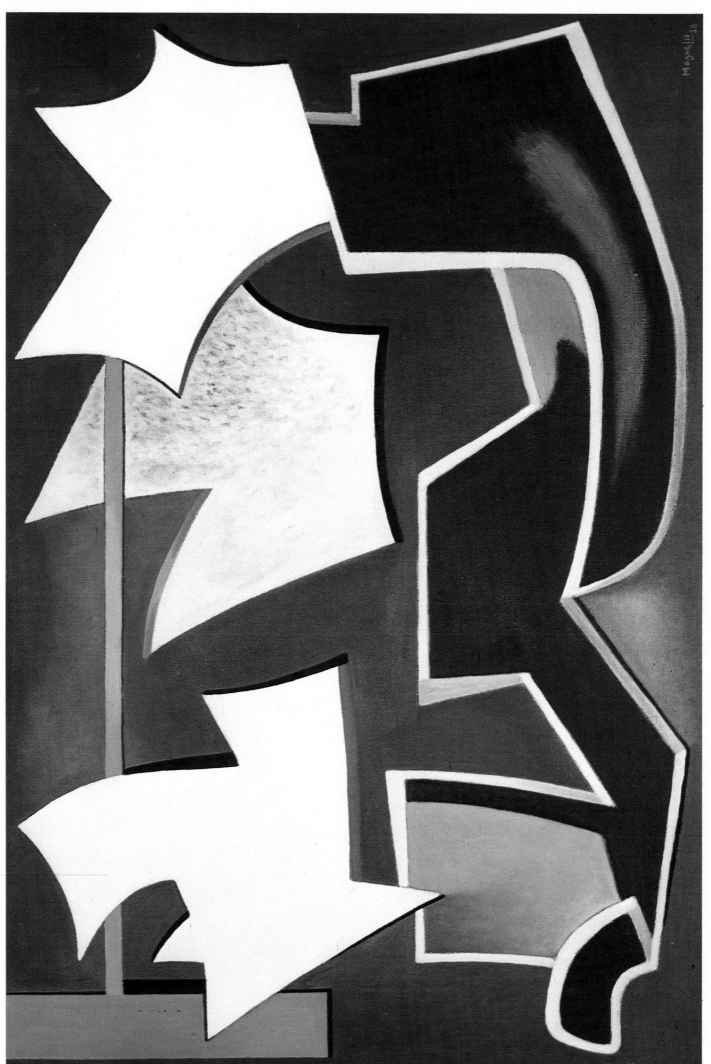

24. ALBERTO MAGNELLI (b.1888) : *Sonorous Border*. 1938. Paris, Galerie de France

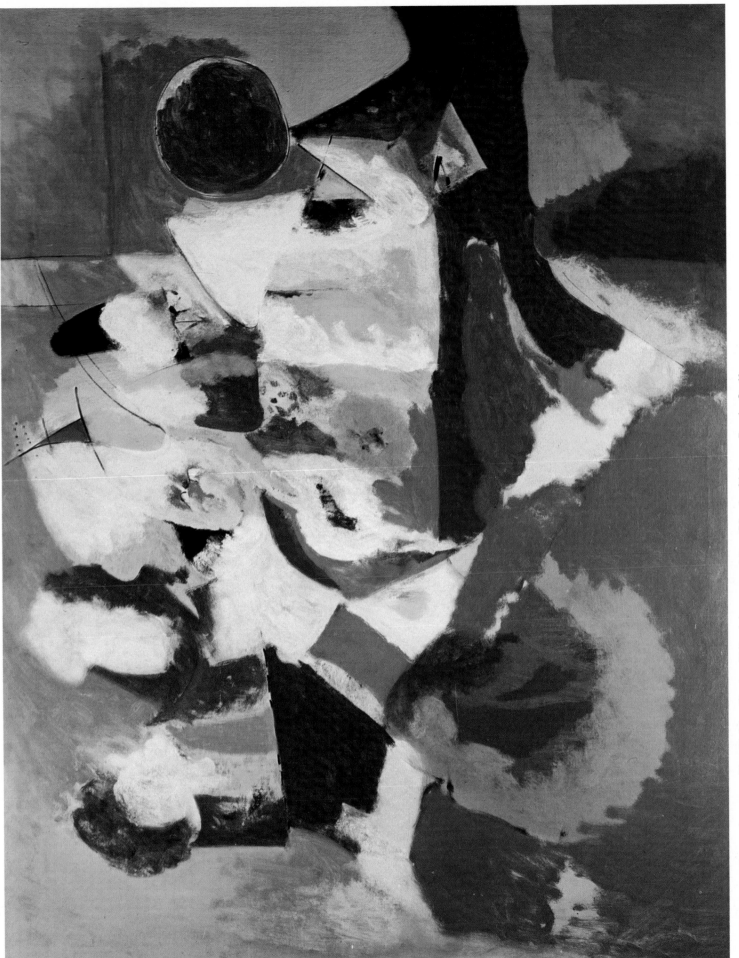

25. ARSHILE GORKY (1904–48) : *Golden Brown Painting*. 1943. New York, Sidney Janis Gallery

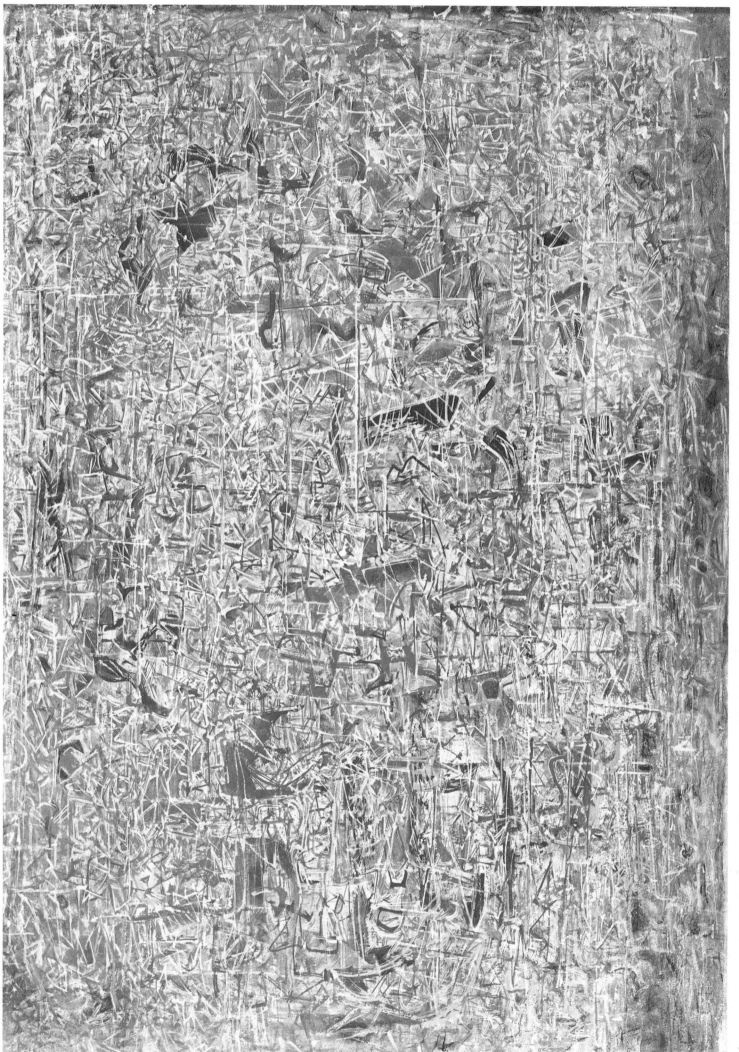

26. MARK TOBEY (b.1890): *Pattern of Conflict*. 1944. Meriden, Connecticut, Mr and Mrs Burton Tremaine

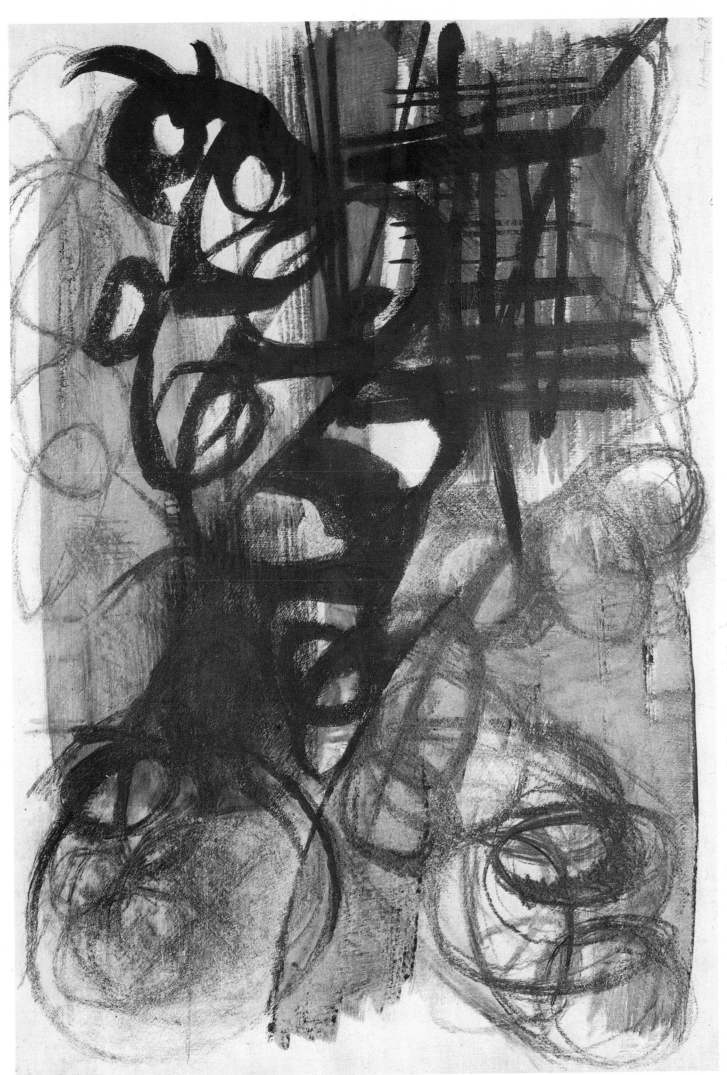

27. HANS HARTUNG (b.1904) : *T.1947.25*. 1947. Paris, Private Collection

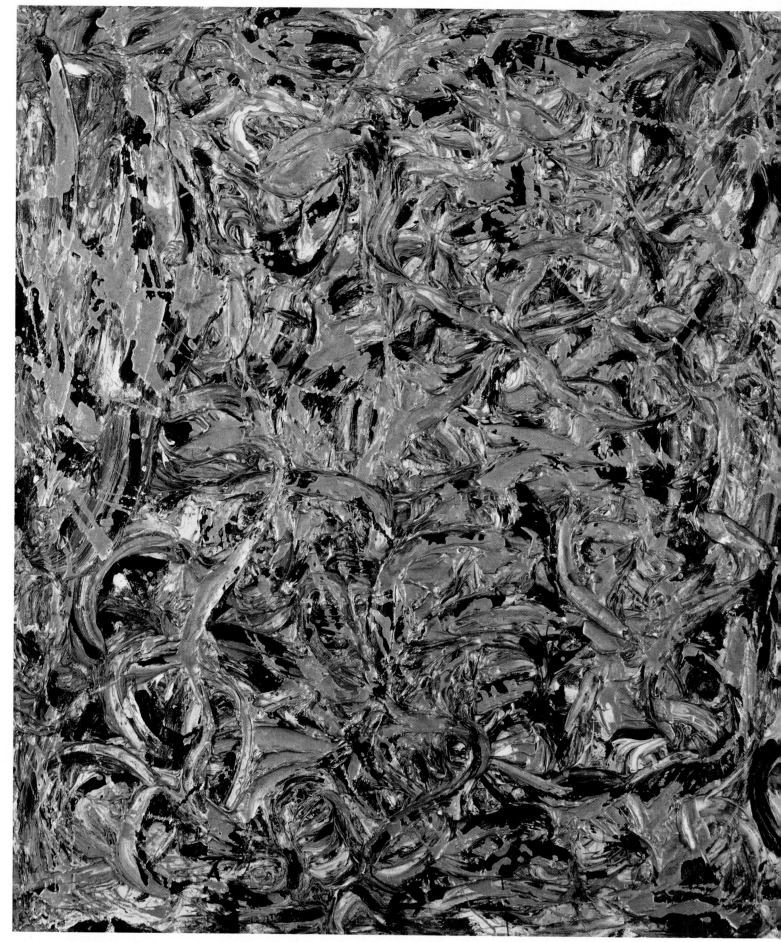

28. JACKSON POLLOCK (1912–56): *Eyes in the Heat II*. 1947. Paris, Galerie Berggruen

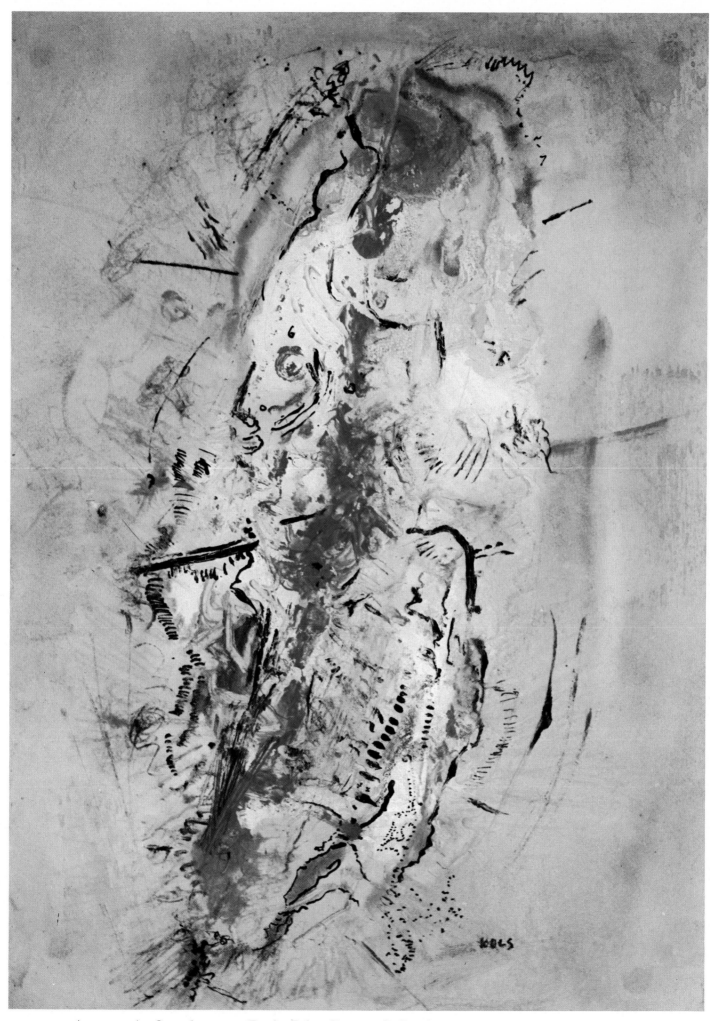

29. WOLS (1913–51): *Gouache.* 1949. Paris, John Craven Collection

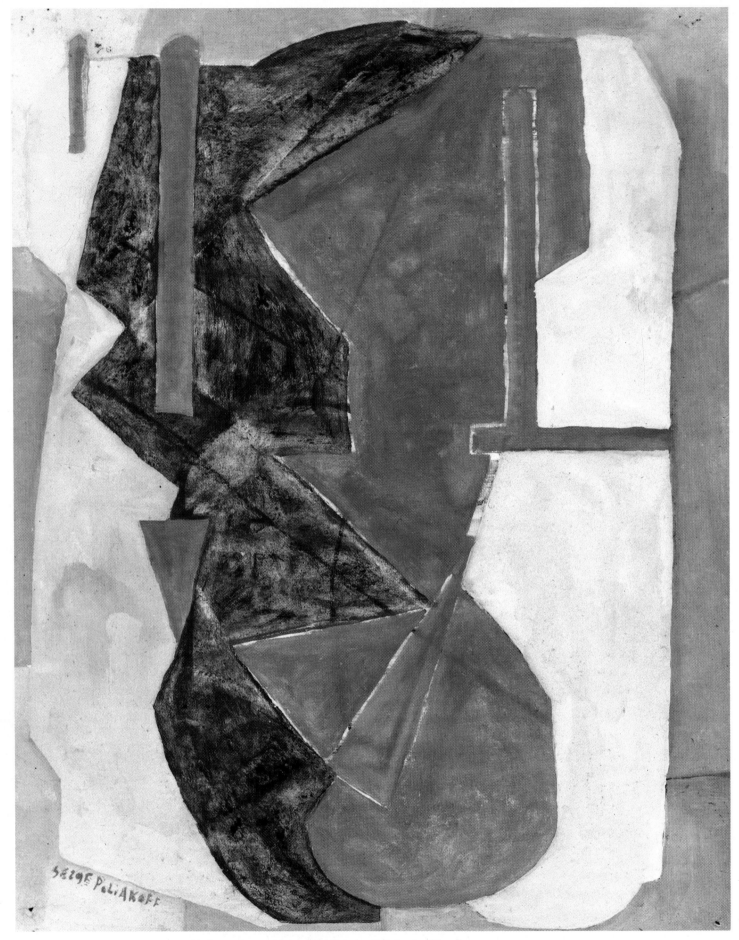

30. SERGE POLIAKOFF (1906–69): *Gouache*. 1948. Paris, M.S. Collection

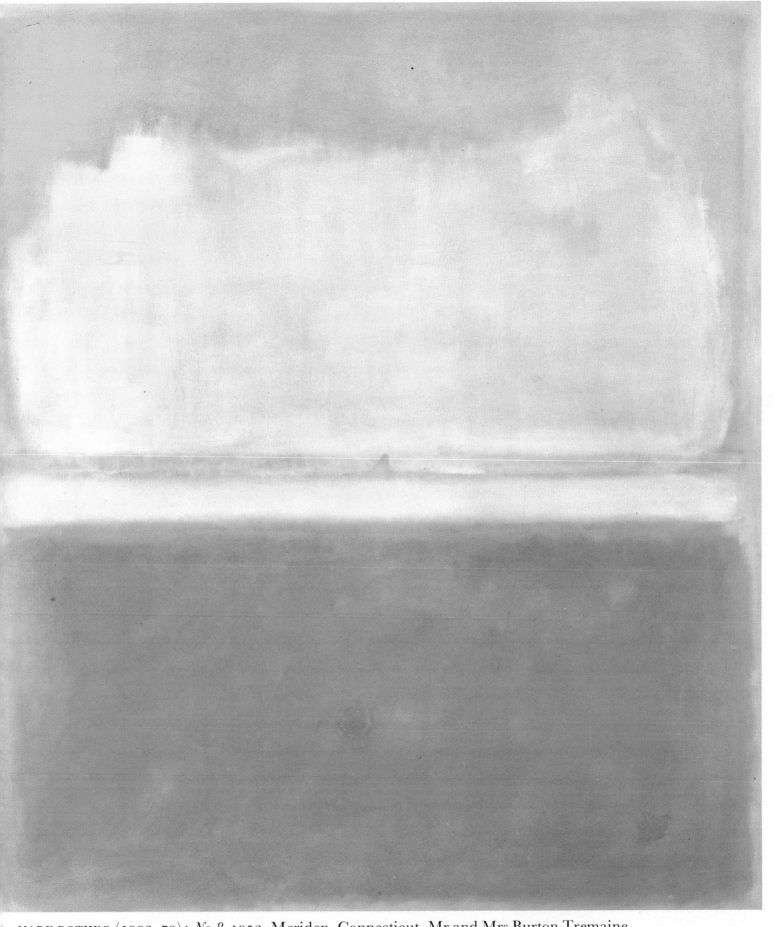

MARK ROTHKO (1903–70): *No.8.* 1952. Meriden, Connecticut, Mr and Mrs Burton Tremaine

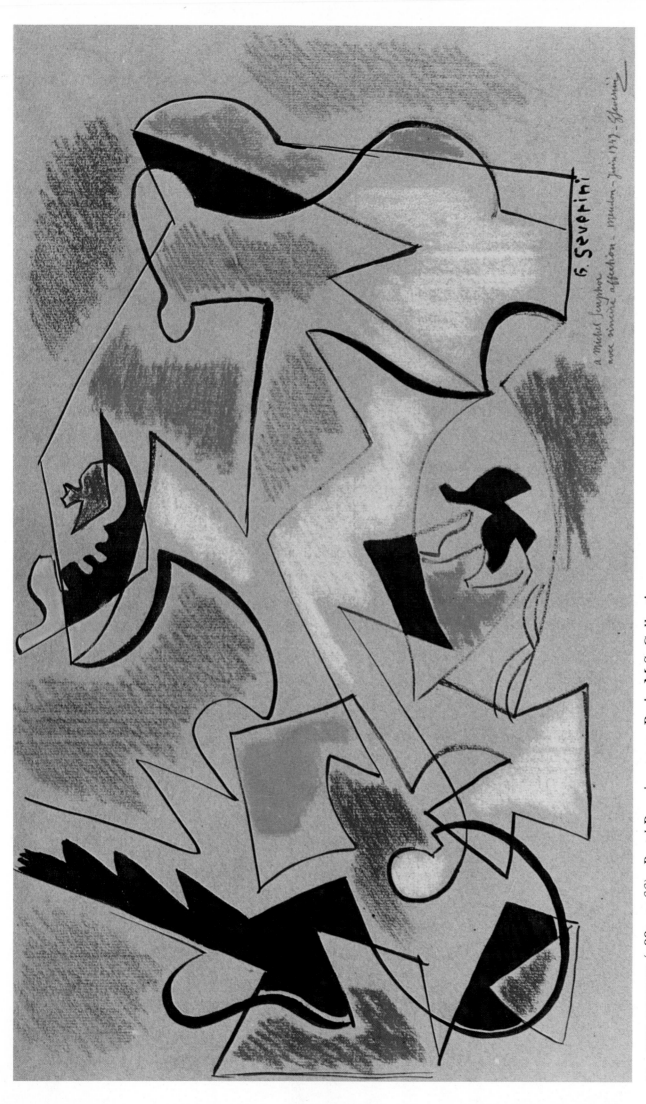

32. GINO SEVERINI (1883–1966): *Pastel Drawing*. 1949. Paris, M.S. Collection

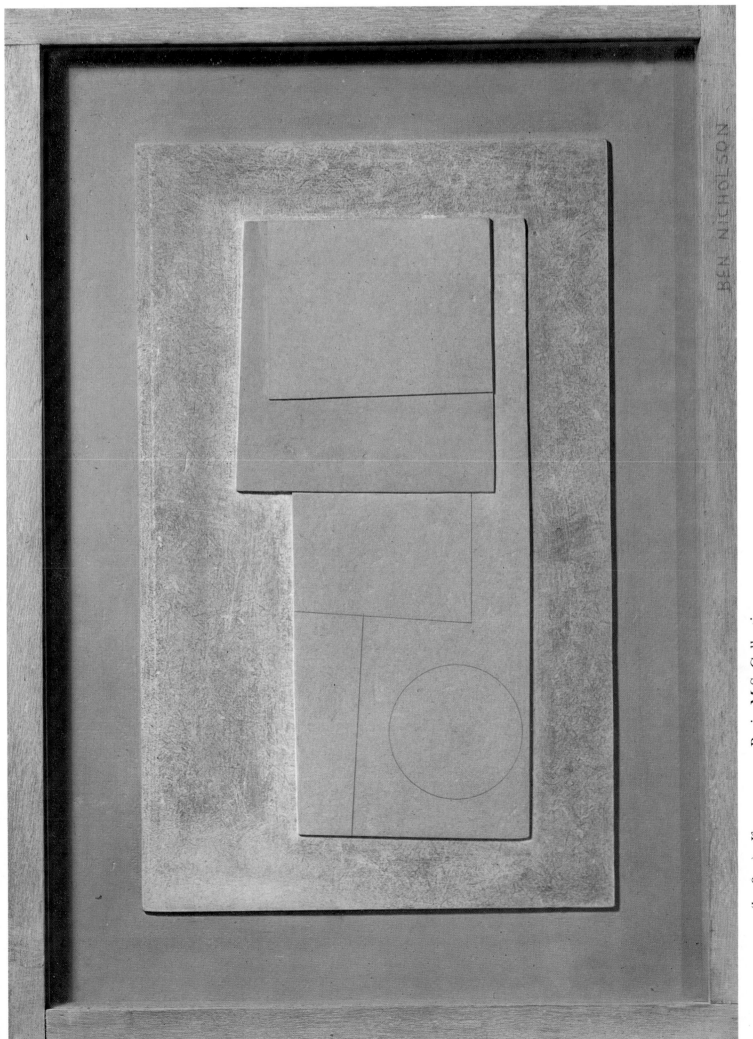

33. BEN NICHOLSON (b.1894) : *Kerrowe*. 1953. Paris, M.S. Collection

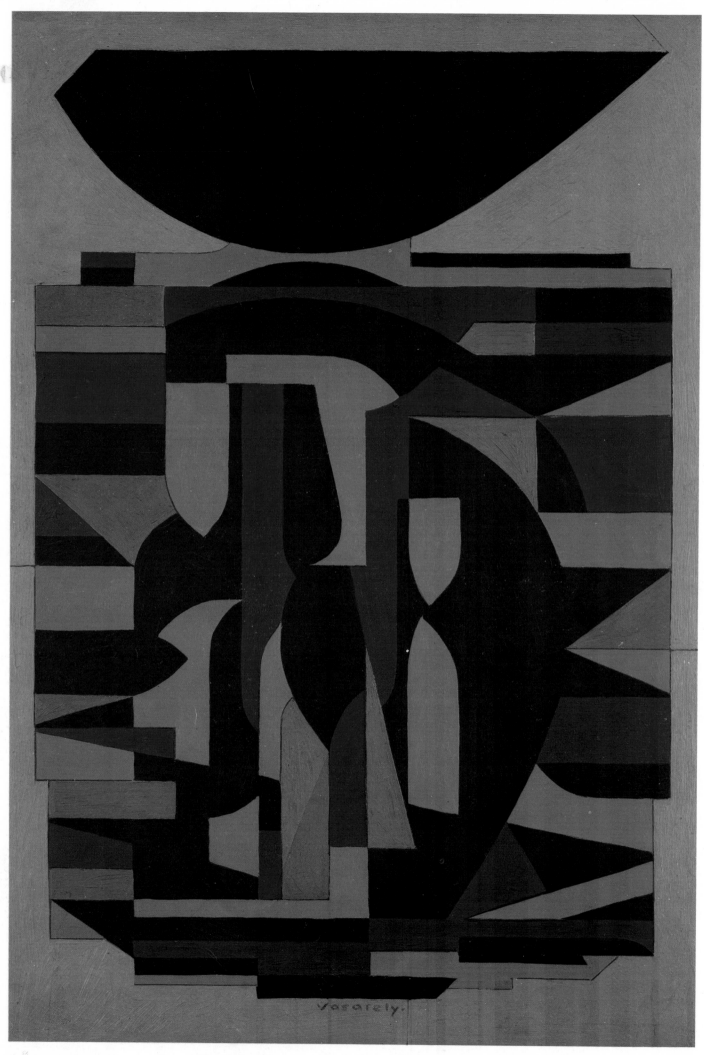

34. VICTOR VASARELY (b.1908): *Sirius II*. 1954. Paris, Galerie Denise René

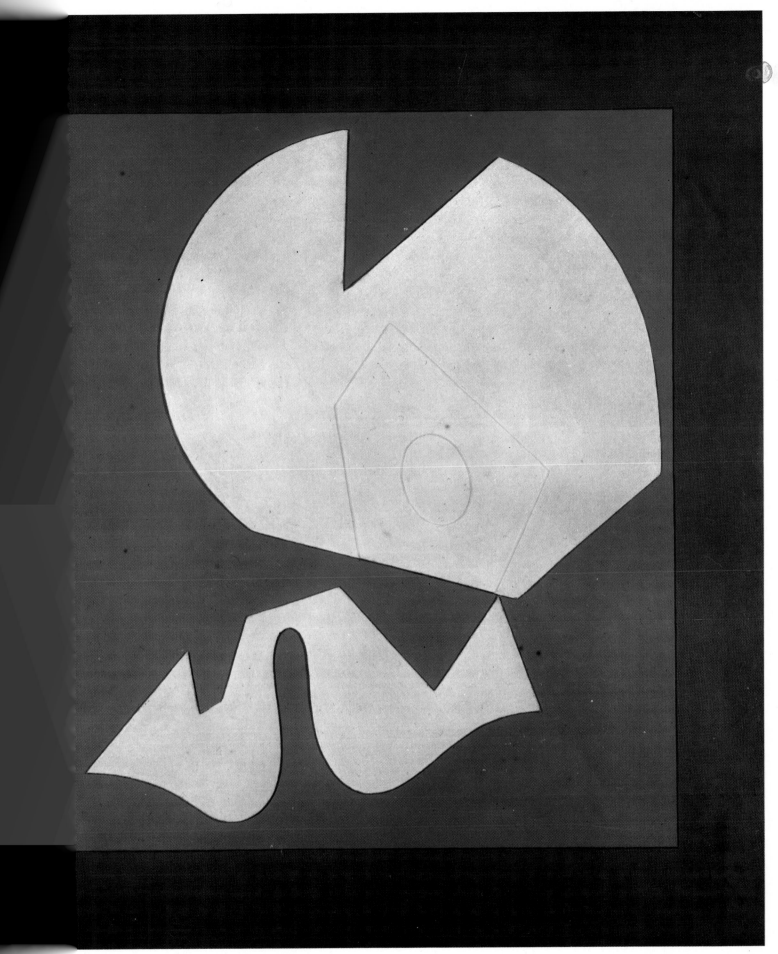

(HANS) ARP (1887–1966): *Morning Geometry*. 1955. Paris, Private Collection

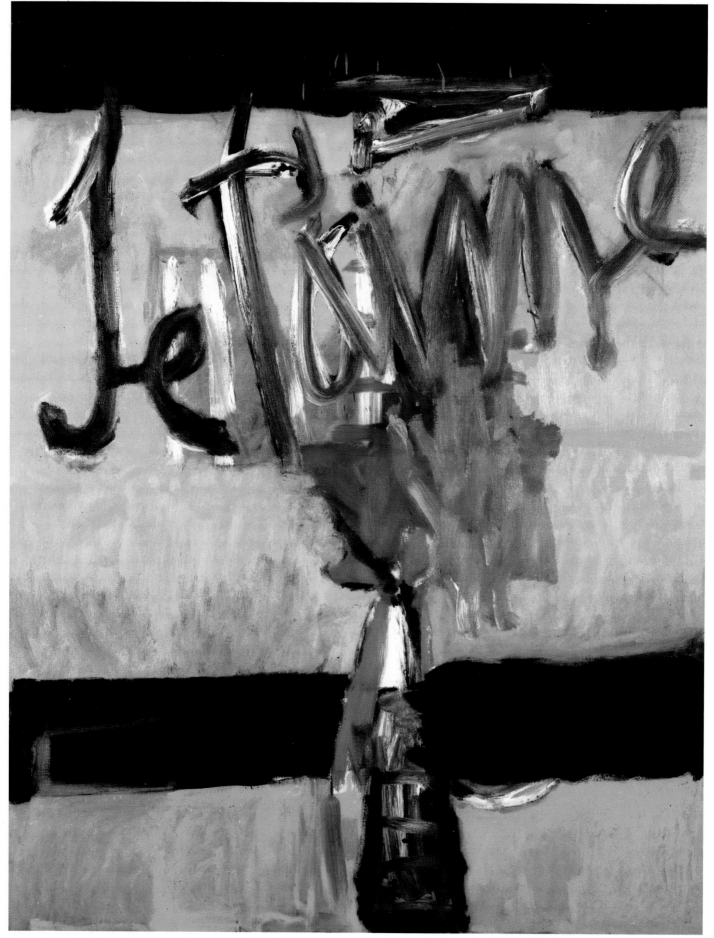

36. ROBERT MOTHERWELL (b.1915): *I Love You IIa*. 1955. New York, Sidney Janis Gallery

ANDRE MASSON (b.1896): *Genesis I*. 1958. Paris, Louis Leiris Collection

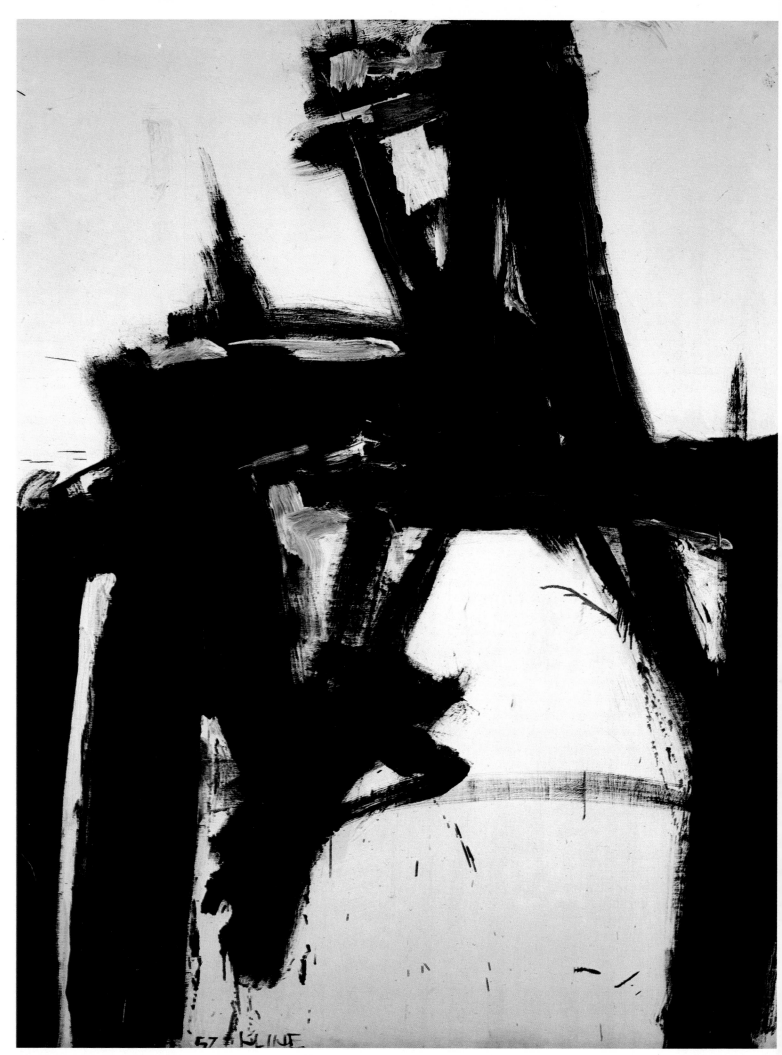

38. FRANZ KLINE (1910–62): *Untitled*. 1957. Düsseldorf, Kunstsammlung Nordrhein-Westfalen

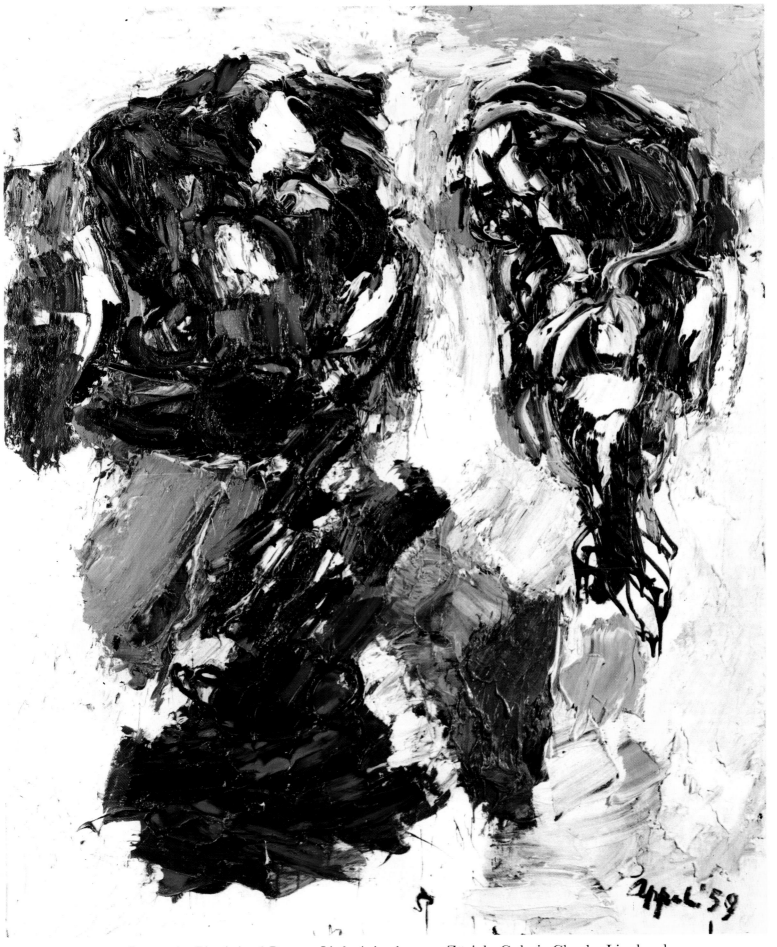

39. KAREL APPEL (b.1921): *Big Animal Devours Little Animal*. 1959. Zürich, Galerie Charles Lienhard

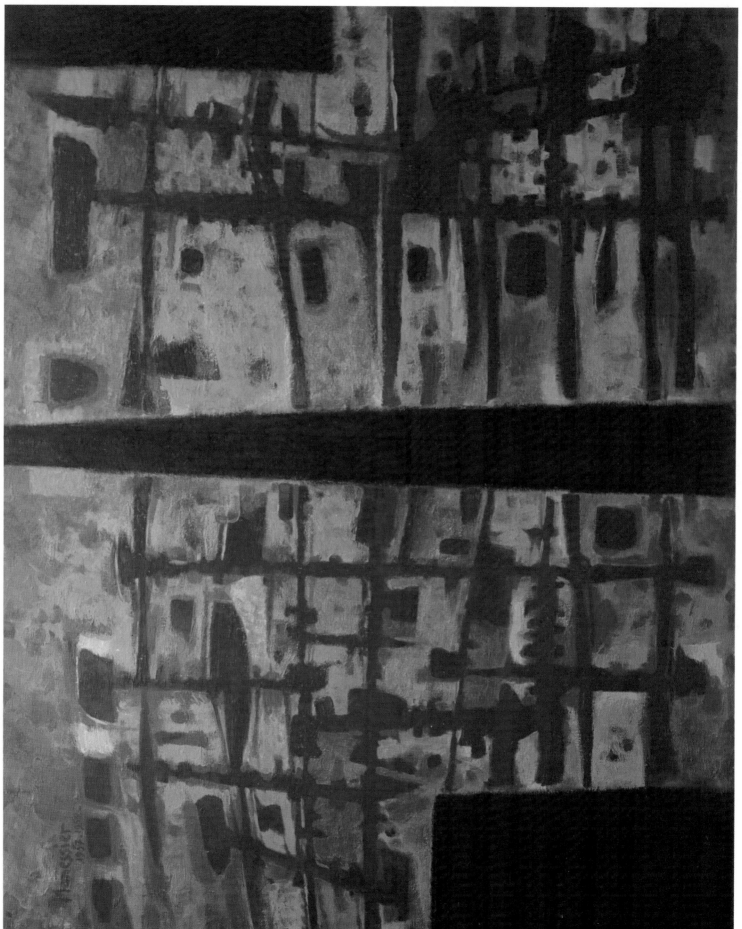

40. ALFRED MANESSIER (b.1911) : *The Sixth Hour.* 1957–8. Paris, Galerie de France

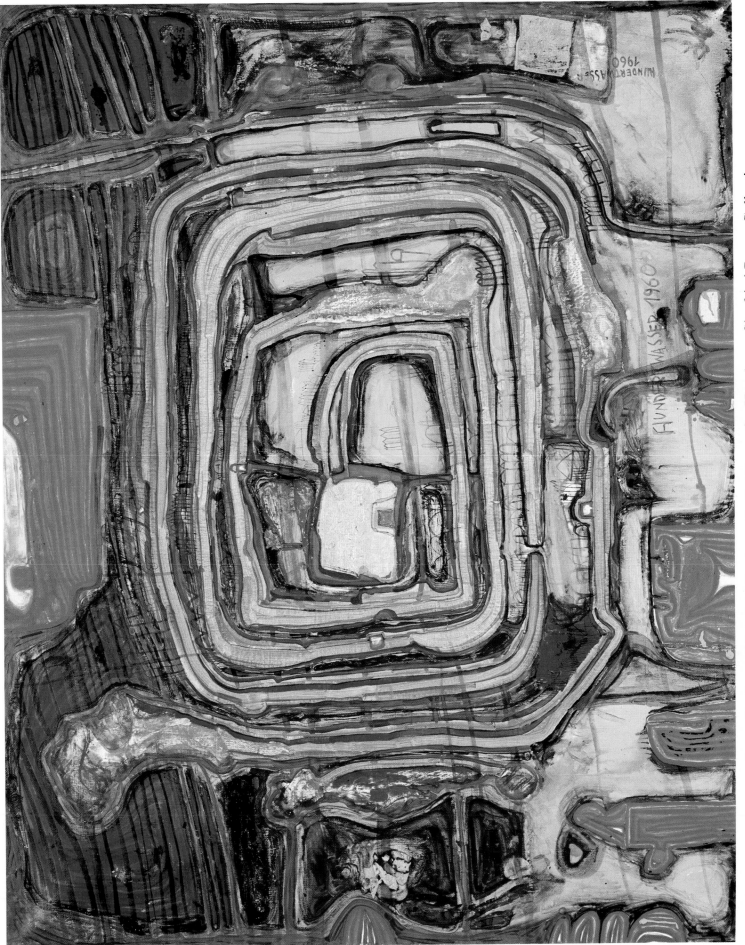

41. FRITZ HUNDERTWASSER (b.1928) : *Sun and Spiraloid Epoch over the Red Sea*. 1960. Hamburg, Siegfried Pappe Collection

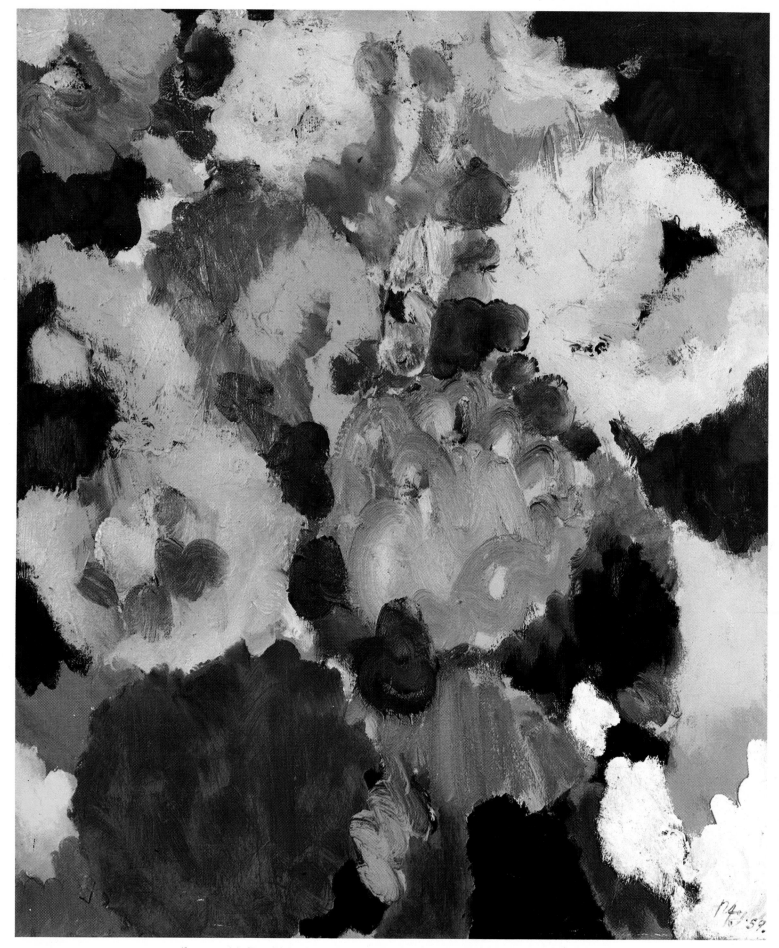

42. ERNST WILHELM NAY (b.1902): *Receding Ochre*. 1959. Cologne, C. Scheibler Collection

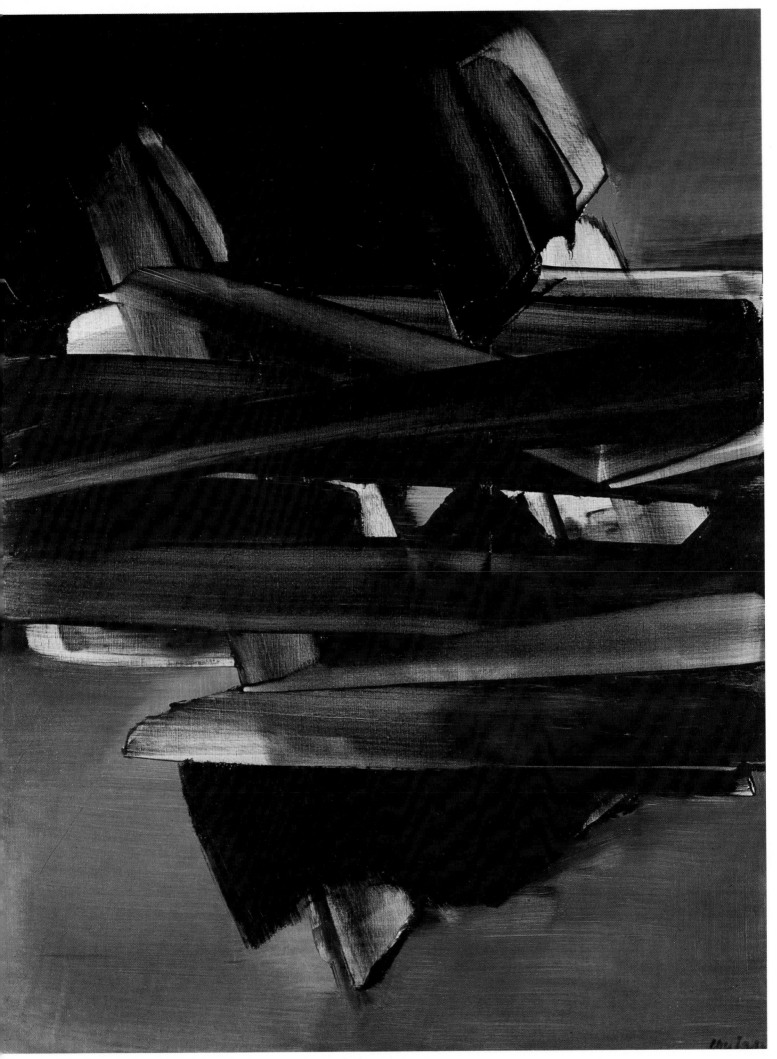

43. PIERRE SOULAGES (b.1919): *Painting*. 1960. Paris, Private Collection

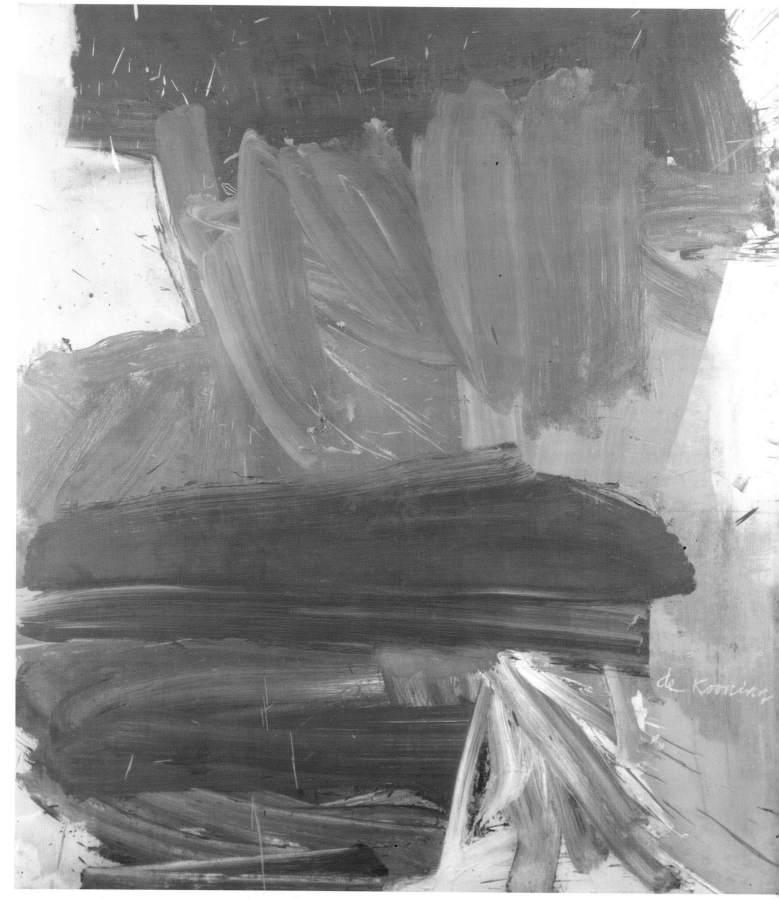

44. WILLEM DE KOONING (b.1904): *Villa Borghese*. 1960. Meriden, Connecticut, Mr and Mrs Burton Tremaine

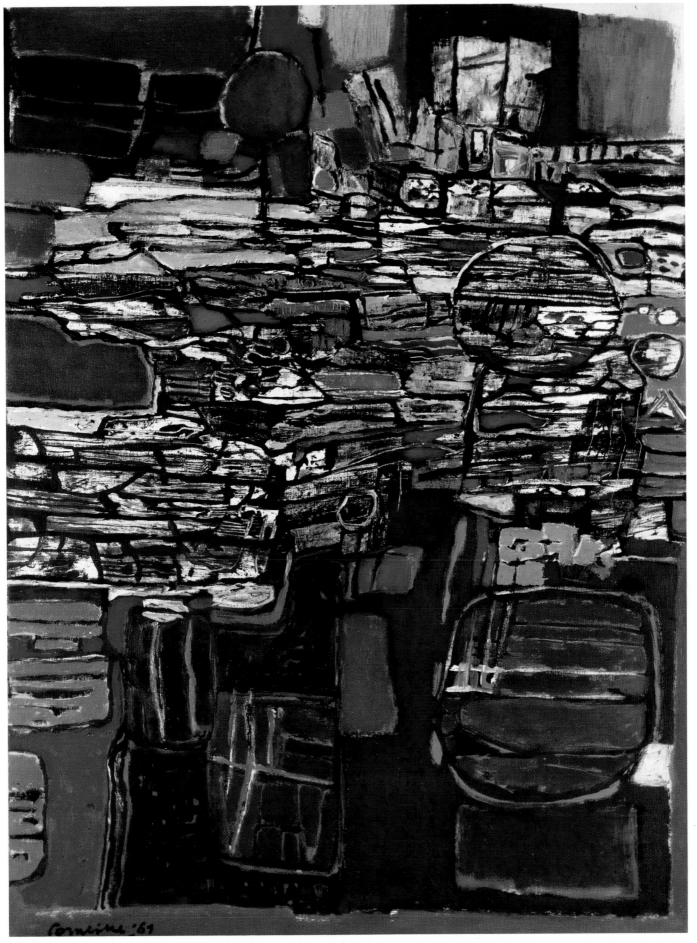

45. CORNEILLE (b.1922): *The Great Rock Wall*. 1961. Paris, Galerie Ariel

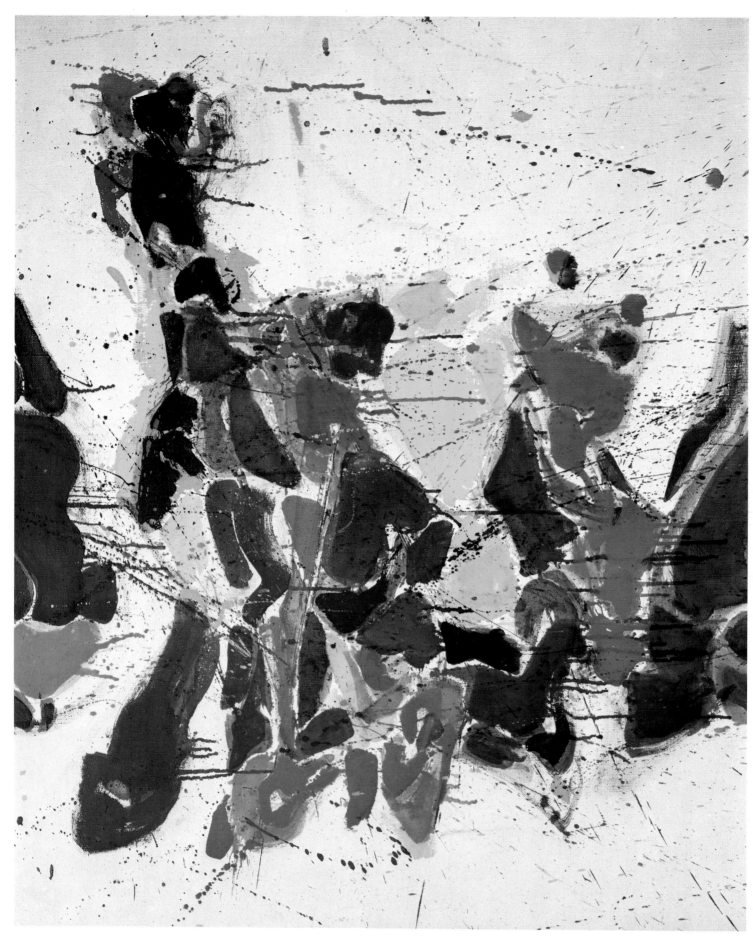

46. SAM FRANCIS (b. 1923) : *Composition*. 1960. Paris, Galerie Jacques Dubourg

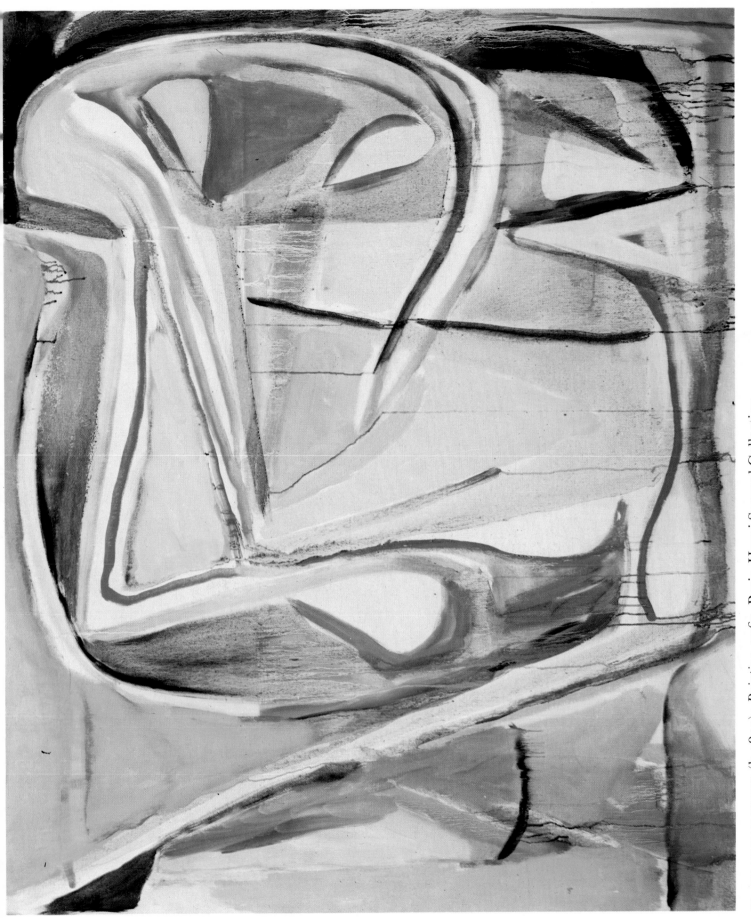

47. BRAM VAN VELDE (b.1895): *Painting*. 1960. Paris, Henri Samuel Collection

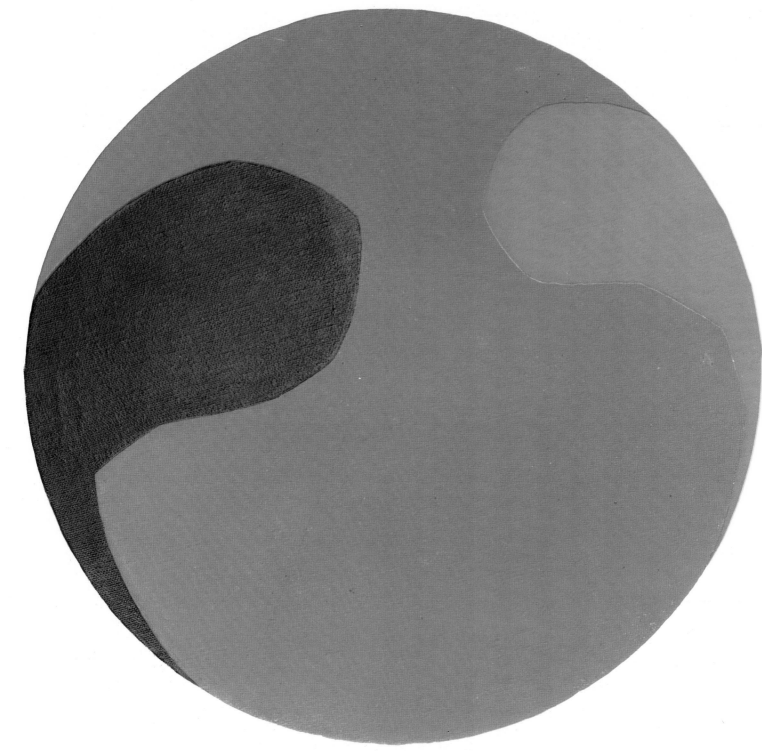

48. LEON POLK SMITH (b.1906): *Prairie Blue*. 1960. New York, Mr and Mrs Arthur Lejwa